Graham Clarke

£8
ART
1914

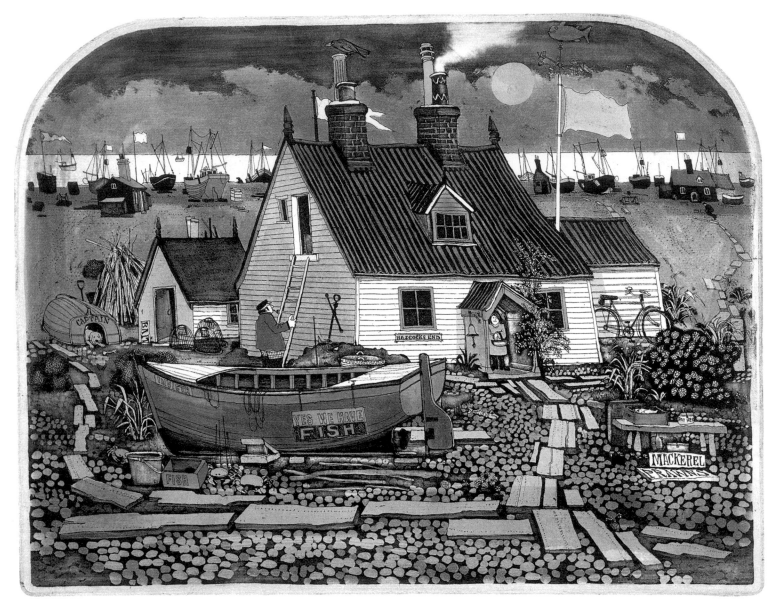

Frontispiece: *Haddock's End*. 1980; published by Christie's Contemporary Art. $10\frac{1}{2} \times 13\frac{1}{2}$ in. Limited edition of 250.

Graham Clarke

Clare Sydney

Phaidon · Oxford

in association with
Christie's Contemporary Art

For wendy

Phaidon Press Limited, Littlegate House, St Ebbe's Street,
Oxford OX1 1SQ

First published 1985
Reprinted 1986
© Christie's Contemporary Art 1985

British Library Cataloguing in Publication Data

Sydney, Clare
Graham Clarke.
1. Clarke, Graham, *1941–*
I. Title
760'.092'4 N6797.C5/

ISBN 0–7148–2383–X
ISBN 0–7148–2436–4 Pbk

Typeset in Ehrhardt 453 by Keyspools Limited, Golborne, Lancs.

Printed in England by Jolly & Barber Limited, Rugby

Unless otherwise stated: all quotations are taken from conversations which the
author had with Graham Clarke between November 1984 and January 1985; all the
original etchings made after 1974 are hand-coloured and printed on Barcham
Green's waterleaf paper, specially watermarked for the artist; all limited editions
are signed and numbered; all the captions were written by the artist and the
author; the *Notes for the Interested* were written by the artist and were originally set
and printed on various Barcham Green hand-made papers by Graham Williams at
The Florin Press, Biddenden, Kent.

Graham Clarke's work photographed by Miki Slingsby.

Contents

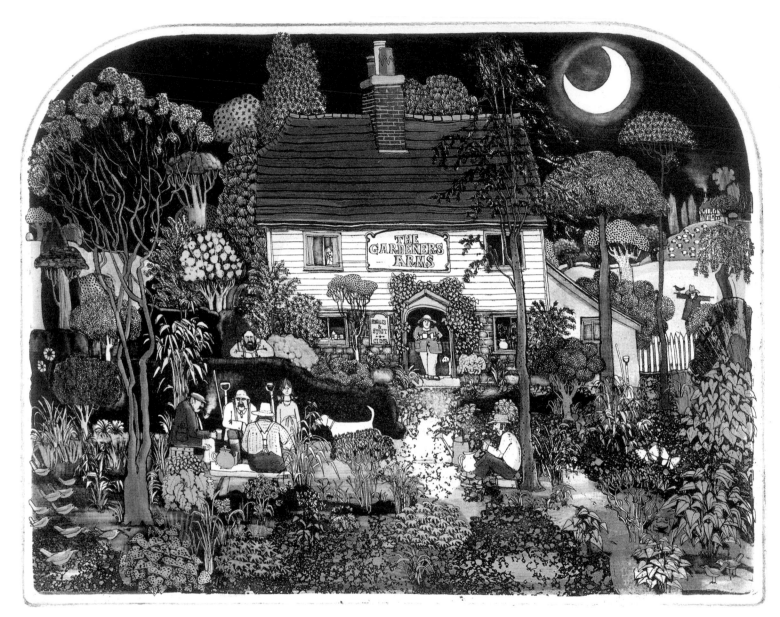

1. *Brewup.* 1982. $10\frac{1}{2} \times 13\frac{1}{2}$ in. Limited edition of 300.

This illustrates the artist's own pub, 'The Gardener's Arms', which he created in the cottage in his back garden. 'This cottage was lived in for sixty years by "Myrt", Myrtle Medhurst, who was a professional gardener in her younger days for several large houses in the neighbourhood. She was thought to be a witch by the local children because of her marvellous cackle. In fact, she was a very nice, if eccentric old lady, and her informal cottage garden, now part of ours, is kept in her memory.'

Graham Clarke

'You're very good at art.' A kindly Miss Britcher spoke encouraging words to a five-year-old at his primary school easel. The accolade was useful; it appointed the new boy to a special place in the class. But in other ways, it was unnecessary; Graham Clarke already knew he was 'an artist'—a precocious self-knowledge endorsed by his ability to correct his father's drawing of a Spitfire. From an early age Graham took his art very seriously. A clay car had to look like a car to satisfy him. And when his painting of the *Santa Maria*, with its red crosses on grey-white sails, went up beside the best in the school hall, Graham realized to his dismay that the sails were rigged to blow in the wrong direction. No one but Graham seemed concerned. His Granny Spencer referred to his work at 'scribbling', which further upset a small boy who sought precision, and knew a mistake when he saw it.

It is tempting to lay too much emphasis on the small incidents of childhood in trying, retrospectively, to give a life a readable shape. In Graham's case, these glances back into his early life, far from falsifying the picture, only serve to confirm the portrait of a man whose personality, outlook and ambitions have remained remarkably consistent. As his later friend and apprentice David Birtwhistle has said: 'Graham is one of the least changed people I know.' Other close friends attribute his self-assurance to some quiet inner guidance. It seems that Graham was as proudly convinced about his status as 'the class artist' as he is about his current role in the community of Boughton Monchelsea, where he now lives. At five, his conception of what exactly that role entailed was still dim. He was 'good at drawing' and this stimulated admiration; but quite soon, he was to exercise other talents for conjuring, comic turns and music-making, in order to astound and to amuse. Nowadays, Graham Clarke is less likely to call himself an 'artist', more likely to describe himself as an entertainer, in the broadest sense of the word. On the other hand those who know him well pay tribute to him as, above all, a kind and generous spirit, a 'good Christian'. For in the shadow of the larger-than-life comic, with his 'squeeze-box', his bag of tricks and teasing jokes, is an equally

positive figure: the gentle, caring husband, father, friend and neighbour, often anxious for others' welfare, and always sincere. The characteristics common to all these aspects of his nature are a desire and a very successful talent to please.

As a visual artist, Graham's talent derives largely from his sharp eye and from his memory for the kind of detail which evokes what is ancestral and secure: detail which will captivate his audience's childhood imagination. The uncertainty of his own earliest wartime years was soothed by an awakening awareness of some immutable rural past: ancient hills and ancient hands on the plough, tranquil cottage gardens, where rose and cabbage, turnip and sunflower are happily nurtured in the same bed.

Graham Arthur Clarke was born on the 27th of February 1941 in an Oxfordshire village where, soon after the outbreak of the Second World War, his mother and Graham's elder brother Anthony were evacuated from their home in Hayes, Kent. The rectory which took them in provided the first and, in the event, last of several temporary ports of call. Soon after Graham's second birthday, they spent a few months in Cornwall, in the tiny cottage of a slate quarryman in the village of Delabole, from where a walk 'down steep winding lanes to Trebarwith', to a vast expanse of sandy beach, boats and blue water, left Graham with a vivid impression. In subsequent years, family holidays at Broadstairs and Looe always left him with a calm feeling of well-being which was to draw him back instinctively to the coast. For the time being such moments were rare, and when the flying bombs started, Mrs Clarke had to uproot the boys again and move back from Hayes to what Graham later described as 'the dreaded rector' in Oxfordshire. He was three and a half by now, and his eye for caricature and gentle exaggeration were already strong if we are to believe this recollection of his host as 'seven or eight feet in height and shrouded in a great dusty black marquee of a cassock, tied at what would have been his waist, with white whiskery string. He pumped the days' supplies of water from an ancient pump in the cobbled yard, repeating his curses in time with the jerking handle. This work done, he was free to take it out on his herd of milking goats and any babies, mummies and toddlers foolish enough to cross his path. Just what made him enter the service of God was an eternal mystery and, if God Himself did have an answer, He was not letting on. Perhaps, He was as confused as the rest of us.'

Graham spent his fourth birthday at home in Kent and the occasion was marked by a pleasanter memory, the gift of a picture book, *The Flippets. A Story of the Rabbit, Fox and Badger* by Margaret Ross. Each page framed a finite, settled and unthreatening world which appealed and still appeals to Graham. The book has been handed down and is now a firm favourite with his own youngest child. The complicated underground warren, the arched openings cut in the earth to form doors and windows for the animals, and the

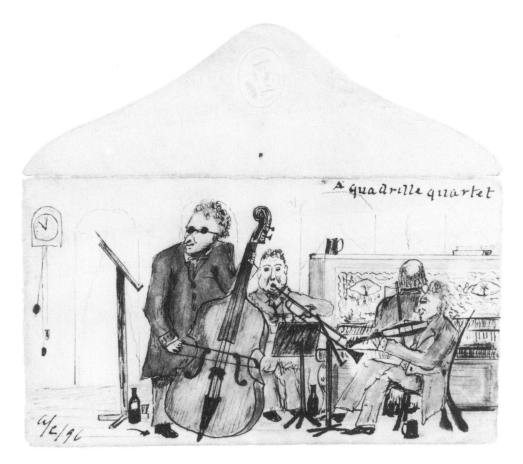

2. A. Mason Clarke, *A Quadrille Quartet*.1896. Pencil and ink, $3 \times 5\frac{3}{8}$ in. Signed and dated 'A/C/96'. Collection Wendy and Graham Clarke.

This drawing was sketched on an envelope by the artist's Great Grandfather.

cosily furnished cottagey interiors had a strong influence on Graham's imagination. Alison Uttley's romanticized country world of Little Grey Rabbit, and the friendly community of Toy Town on 'Children's Hour' were to work the same magic, and both compared reassuringly with the standardized suburbia to which the family had returned in 1945.

The Clarkes' home in Hayes was one of a row of 1930s, three-bedroomed, semi-detached, pebble-dash houses 'with pink paving stones', Graham recalls. From here his father, Maurice Clarke, could commute to Catford and to his job at the Midland Bank. Life assumed its regular and respectable division into work and leisure. In their spare time, both sides of the family were musical. Graham's great-grandfather, Arthur William Mason Clarke, had been a solicitor's clerk and a good amateur violinist; he compiled two popular handbooks, *A Biographical Dictionary of Fiddlers* (William Reeves, 1895) and *The Violin and Old Violin Makers* (William Reeves, 1910, reprinted, 1957). He also considered himself something of a dab hand with pencil and paint brush (Fig. 2), and it is said that when the family were short of money, he would don his smoking cap and velvet jacket, rush upstairs to the attic, choose a postcard, copy the view in oils and sell it the following

3. *Miss Jay's Wood*. 1950. Watercolour, 9 × 12 in. Signed 'G. Clarke'. Collection Dr R. J. Bishop.

Painted on the back of a Christmas cracker box in the Misses Jay's wood when the artist was nine. It was probably his first painting from 'nature' and was bought by a neighbour, mother of the present owner, for ten shillings.

4. *Miss Jay's Wood*. 1952. Oil on board, 10 × 14 in. Collection Mr and Mrs Raymond Hudd.

This is the artist's first oil painting, done when he was eleven years old. Painted on Boxing Day.

5. *The Rehearsal.* 1965. Acrylic on board, 14 × 11 in. Collection Mrs J. Southcombe.

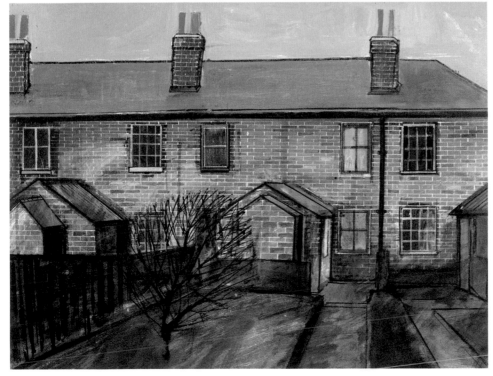

6. *Palace Road, Bromley.* Royal College of Art Diploma Show, 1964. Acrylic on board, 15 × 18½ in. Collection Wendy and Graham Clarke.

This painting shows the back of a terrace of Victorian artisans' houses in Palace Road. The second building from the right with brown window frames is Number 77, the artist's house, just 11 feet 6 inches wide.

7. *Hayle Mill.* 1974. Black and white etching, $4\frac{3}{4} \times 8\frac{1}{2}$ in. Limited edition of 75.

Produced at the request of Rémy Green, who was then the Managing Director of this little hand-made paper mill in the Loose Valley not far from our home in Kent.

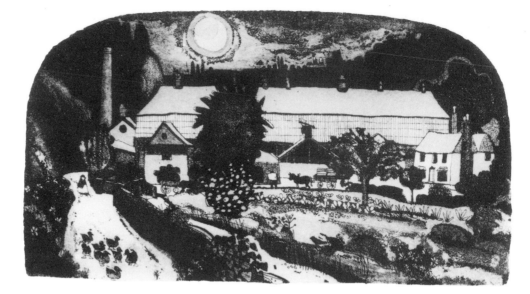

morning for ready cash. Unfortunately, this colourful member of the family enjoyed his drink, and eventually disappeared to Australia. His son Arthur, Graham's grandfather, was an equally gifted fiddler, and would make up his father's trio when it was asked to provide light classical music at wedding receptions. In 1949 the Clarkes took a larger house in Bromley so that Grandfather Clarke, now a widower, could move in with them and bring his antiques, his Dickens and his musical bygones along too. Graham remembers him fondly as the kind and warm-hearted old man who transmitted his enjoyment of Cruickshank, of the fine grain of violin backs pictured in his *Strad* magazines, and of the occasional 'scroop', as he called the violin playing which he carried on until well into his old age.

The Spencers, on the maternal side of the family, also had artistic leanings combined with a strong practical aptitude. Graham's grandfather, George Spencer, had been a cutter of blouses and dresses in the rag trade, and it was here that he met his future wife, Lillie. Lillie was descended from an old Jersey family, the Le Bretons. Her father, John Le Breton, continued the family trade of coachsmithing, but could boast a celebrated cousin in Lillie Langtry, and christened his daughter after her. Lillie and George Spencer are cherished in the family's affection for their bread pudding, their simple, humble ways, and their innate goodness. Grandfather Spencer, especially, had a formative and stirring influence on Graham, whose most lasting memory is of 'the good English sentiment' expressed in a motto which had been saved from a Christmas cracker and pinned above a bench in his grandfather's workshed: 'The only real failure is to give up trying.'

Graham is remembered from this time as a bright and breezy, good-natured, peace-loving and sociable young boy. His mother describes an 'alert,

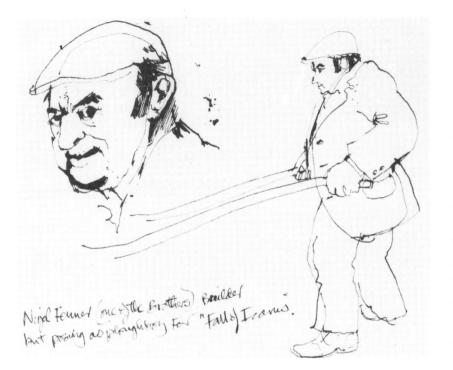

Nigel Fenner (one of the brothers) Boulder
but posing as ploughboy for "Fall of Icarus".

8. *The Fall of Icarus Fenner*. Published April 1978 by Christie's Contemporary Art. $13\frac{1}{2} \times 21\frac{1}{4}$ in. Limited edition of 200.

'This scene shows Icarus a few seconds prior to his actual fall at a place not unlike Porthleven in Cornwall, where Mick Fenner lost his teeth over the side of a fishing boat on the first day of his holiday. It is a truly allegorical picture as although Mick is famous for having large sticking-out ears he cannot fly. The story of how his teeth subsequently re-appeared in a tin of Porthleven Crab Soup is so well known that I will not repeat it here. However you may read about it if you must in "Twentieth Century Cornish Dental Phenomena" by Nigel Fenner (his brother) who was incidentally proud to pose as the ploughboy for this etching.

P. Bruegel refers, of course, to Percy Bruegel the Elder (whelk fisherman and second best coarse euphonium player in Kent).' From *Notes for the Interested*.

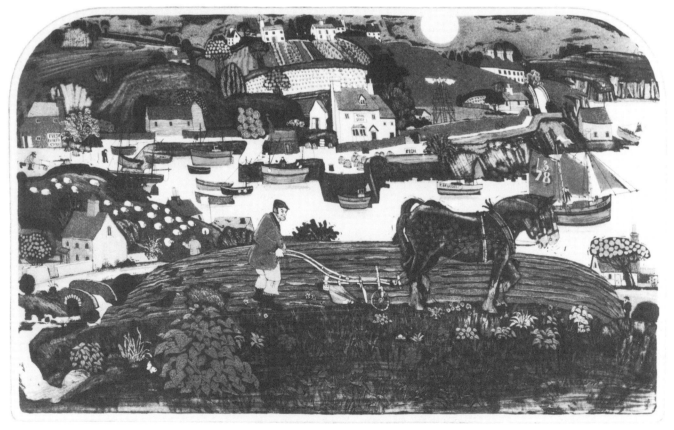

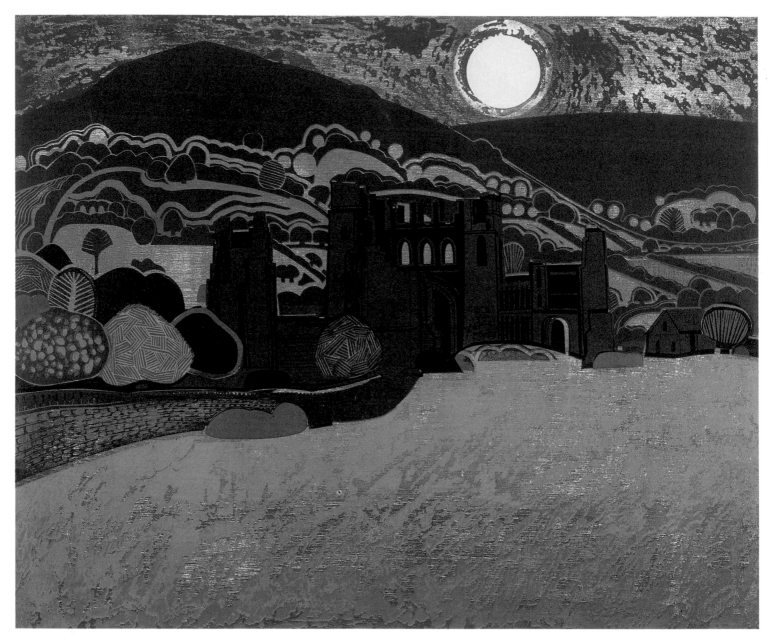

9. *Llanthony Priory*. Autumn, 1967. Blockprint, wood and linocut, 20 × 24 in. Commissioned by Shell. Printed in 12 colour blocks on J. Green mould-made paper.

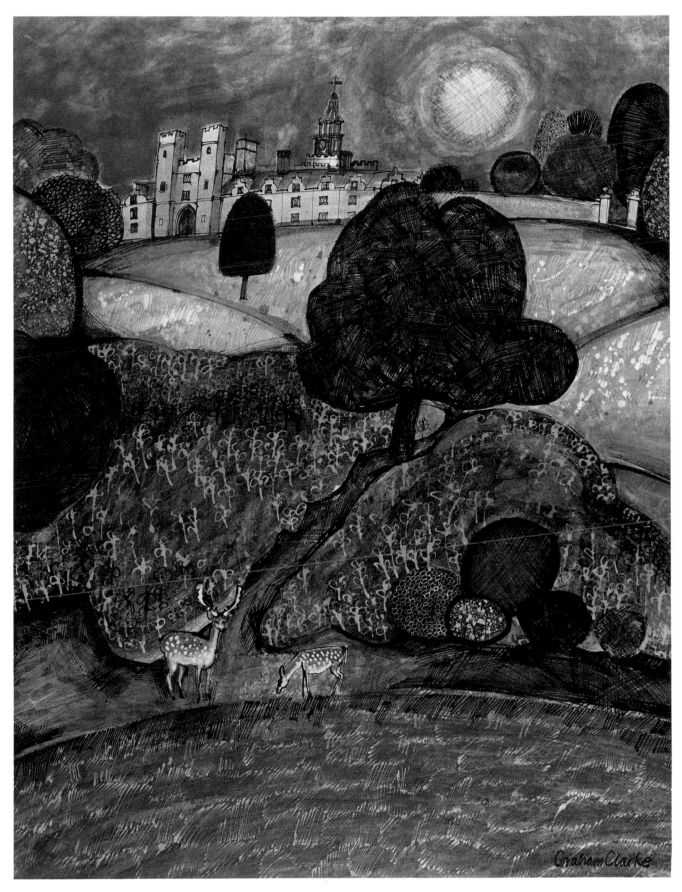

10. *Knole*. Published 1967. Ink and varnish, 40 × 25 in.

This painting of Knole in Sevenoaks, Kent, was commissioned as a poster design by London Transport.

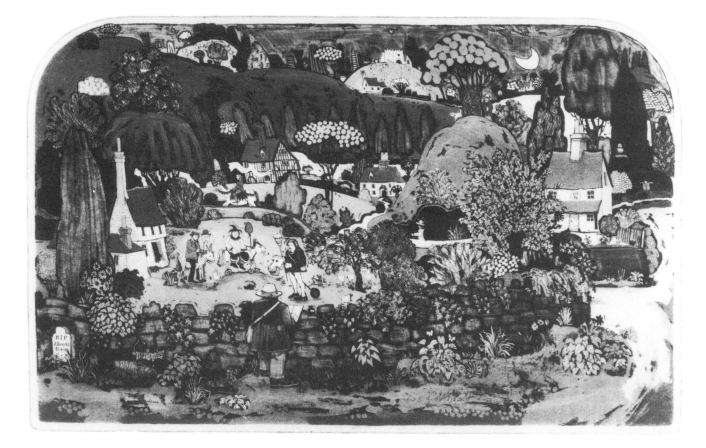

11. *Four Horsemen Wondering Whether to Have an Apocalypse*. Published 1978 by Christie's Contemporary Art. Dated 'Feb. 78' on the right-hand side. Limited edition of 200.

observant and sensitive child, easily moved to tears', and adds that 'he was always busy making or doing something'. According to Christopher Peel, a childhood friend, Graham could keep himself happy, and his friends too, with his inventiveness. Much of his free time was spent out of doors, cycling in his wellington boots to Hayes Common and to the surrounding farms; wading through the two ponds belonging to the Misses Jay (spinster sisters who mothered a bird sanctuary in their private patch of woodland); exploring bombed and empty building sites, which stocked materials more sizeable and exciting than any toy-shop could provide. And, four times a year, Graham

and his brother would be swept into their parents' amateur dramatics. Mr and Mrs Clarke were enthusiastic members of 'The Hayes Players', and rehearsals, costumes and scenery took over the entire household and its timetable. Tony's skills as a set-builder seem to have been more immediately useful than Graham's sporadic contributions as a painter of stage portraits or of stained-glass windows. At quite a young age, Graham knew he preferred the impromptu role of amateur showman to any which meant obediently following direction. His parents did nothing to discourage this line of thought, nor did they insist that he continue piano lessons when it became clear that his talent was based entirely on his ear for music, and was not to be constrained by notes on a page. Graham has never been averse to discipline, but it has to be self-determined and allied to the thrill of his own experiments and discoveries.

There was a period of such excitement when his father bought him a set of stencils, and a box of felt-tipped brushes and spirit-based inks in brilliant shades. As an up-and-coming professional artist aged seven or eight, he rather despised the stencils but derived immense pleasure from handling the oily-smelling materials, as well as from the bold and striking effects he could achieve with the new, quick-drying colours. Already, though, he was beginning to progress from what he knew to be children's pictures to what he now calls 'old ladies' painting'. He began to make watercolour copies from picture postcards of Derwent Water and other Lake District views, and received encouragement, particularly from his mother's sister, Aunt Norah. It was Aunt Norah and Uncle Leslie who presented him with his first big box

12. *Quercus Beserkus*. Published June 1979 by Christie's Contemporary Art. $13\frac{1}{2} \times 21\frac{1}{4}$ in. Limited edition of 250.

'REGULAR READERS OF MY NOTES will already be well aware of the considerable talents and the consequent theatrical triumphs produced by "The Stagefrights", our village drama group. Their fame has naturally spread and one can assume that the box-office problems and general falling off of London audiences witnessed over the last year or two, can be accounted for by the packed houses in our village hall, both on Friday as well as Saturday nights, on several occasions every twelve months, particularly during the second interval when the bar is open.

Incidentally, they have asked me to take this opportunity to let it be known (and without wishing to be unkind) that it's just no use whatever any of your London stage Johnnies coming down here in their velvet jackets expecting all the best parts—and that goes for "Sirs Lawrence, Oliver and Gilgood" too. We are just full up.' From *Notes for the Interested*.

13. *Cottage in a Valley*. 1966/7; published by Editions Alecto. Blockprint in 6 colours, 18 × 26 in. Limited edition of 125.

14. *Big Field*. 1966/7; published by Editions Alecto. Blockprint in 6 colours, 18 × 26 in. Limited edition of 125.

Graham Clarke

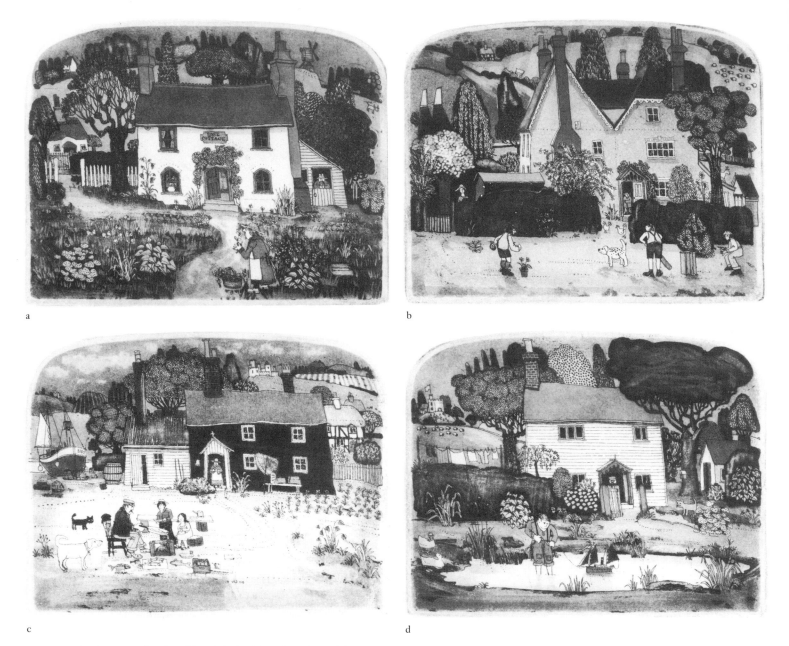

a

b

c

d

15a–h. *Pastimes*. 1980. $5\frac{3}{8} \times 6\frac{3}{4}$ in. Limited edition of 250. A set of eight rural pastimes.

a. *Flora Bundy* b. *Googley* c. *Fryup* d. *Master Mariner* e. *Smart Shoes* f. *Thomas Hardy Annual* g. *Skippers* h. *Squeeze Box*
These were all based on cottages in Kent, Dorset and Sussex which the artist recorded in his sketchbooks.

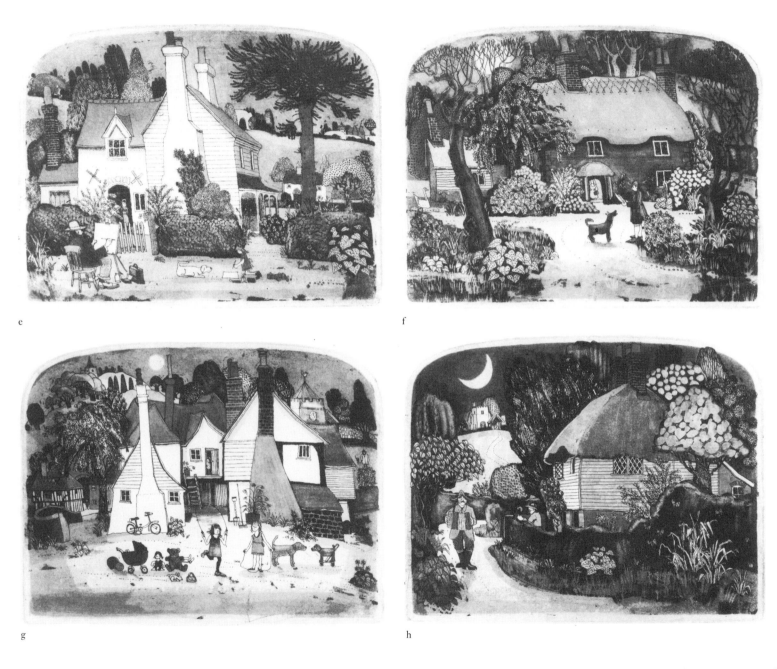

e

f

g

h

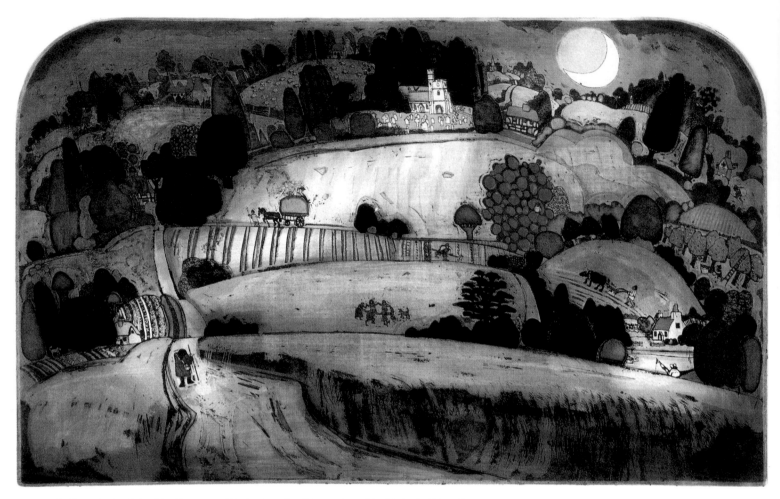

16. *Dance by the Light of the Moon.* 1973. Hand coloured etching, $13\frac{1}{2} \times 21\frac{1}{4}$ in. Limited edition of 50.

The first hand coloured arched top etching.

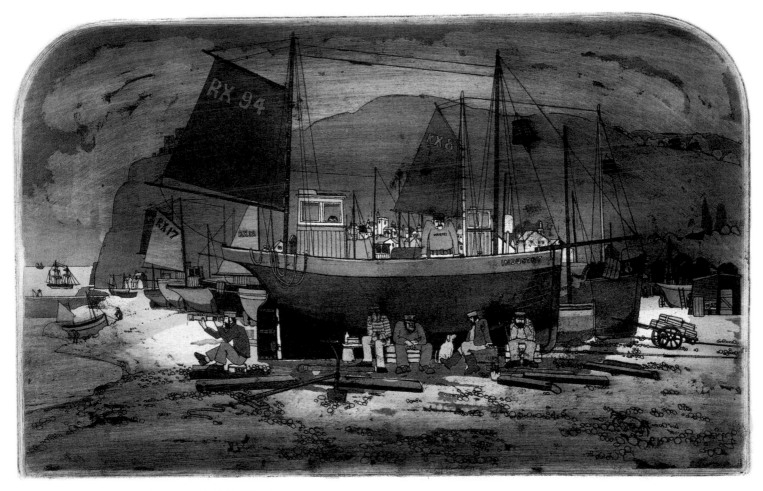

17. *Industry*. 1974. $13\frac{1}{2} \times 21\frac{1}{4}$ in. Limited edition of 100.

18. *Crabbers Retreat.* Published 1981 by Christie's Contemporary Art in conjunction with The National Trust. $10\frac{1}{2} \times 13\frac{1}{2}$ in. Limited edition of 350.

Based on Penberth Cove, West Cornwall.

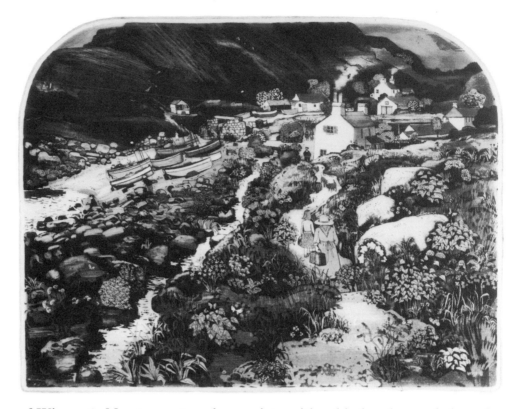

of Winsor & Newton watercolour paints with sable brushes and then, for Christmas 1952, a set of oils and painting boards. On Boxing Day he disappeared into the Misses Jay's wood to paint his first oil (Fig. 4). A watercolour of the same spot (Fig. 3) done on the lid of the Christmas cracker box had already been bought by an appreciative neighbour, Mrs Bishop, for ten shillings—a transaction which confirmed Graham in his conviction that a successful professional sells his art.

Not long afterwards Graham made the discovery that 'the artist' was not necessarily acclaimed in all circles. He was attending a small private 'crammer' school at the time in order to ensure his success in the 11-Plus exam, but had the impression that he was not a star pupil. So, as an attempted endearment at Christmas, he gave each of his teachers a watercolour sketch of Derwent Water which he had carefully mounted in an old photograph frame. The response clearly implied that 'art' was not on the Proprietress's list of worthwhile futures, and only too clearly stated that Graham would 'never have tuppence ha'penny to rub together'. Not surprisingly, his gift did nothing to influence her assessment of him. But Graham made the grade none the less and entered Beckenham and Penge Grammar School in 1952.

Thereafter, Graham and his group of friends at 'Penge University'—as it was disparagingly nicknamed in honour of the Goons—preserved a nonchalant attitude to exams. Disciples of Spike Milligan kept school-work in

proportion. Graham's relative success at geography and history can be attributed to the excellence of his map-making, and to his fascination with the romance of the past, with castles and costumes and, particularly, with the workaday lives of ordinary people. Then he discovered *1066 and All That* by Sellar and Yeatman, and no school history lesson ever lived up to that hilarious cobbling of facts with its ludicrous drawings by John Reynolds. Graham's interpretation of the Biblical past was noted even at school for a broad-minded, homespun wisdom which bypassed accepted theology and shed new light in the religious education class.

The highly personal contribution which Graham made to classroom discussion was matched by a mild disrespect for authority and a desire to strike out independently. For Christmas 1953, he received a copy of the newly published *Down with Skool*, and found his mood so exactly in tune with Ronald Searle's illustrations that he cultivated caricature himself, both on the page and in his person. One day Graham made an appearance in the school German lesson wearing a pair of Lederhosen. On another, he upstaged the 'Edwardian' members of staff by adopting a well-Brylcreemed centre parting. But, on the whole, school went its routine course, and Graham's humour was only allowed its full expression outside the classroom. Art seems to have been the only ground on which school and extra-mural activities met with any zeal. Graham continued to take his painting and drawing very seriously, and returned after each summer holiday with a fresh batch of drawings and seaside sketches.

The art master in Graham's first year at Beckenham Grammar School was

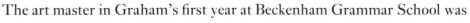

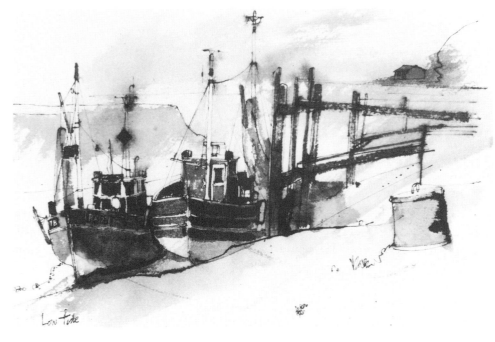

19. *Low Tide.*
Sketchbook Vol. 5.

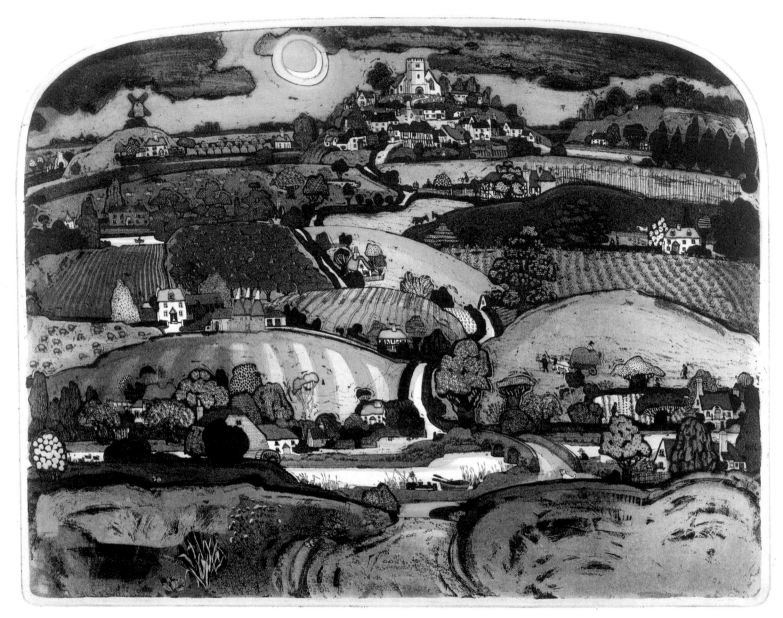

20. *High Weald.* 1975. 21¼ × 27¼ in. Limited edition of 100.

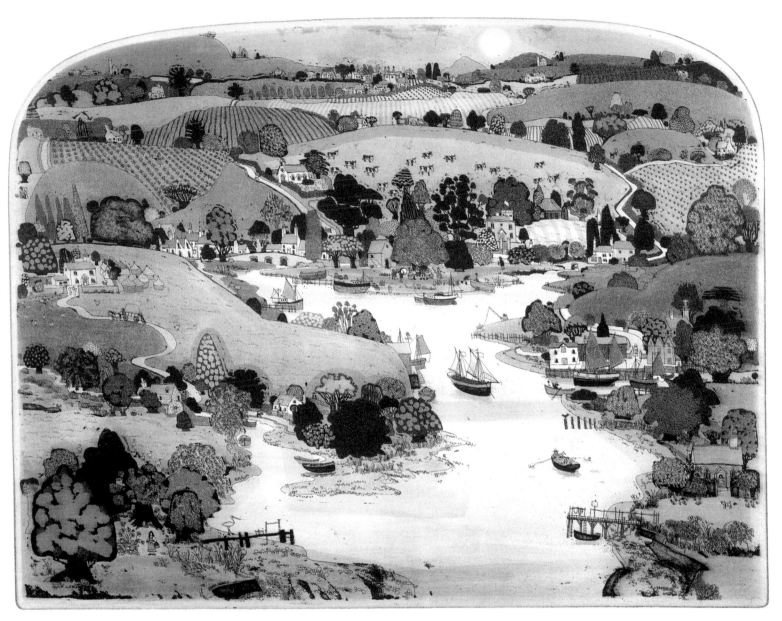

21. *Late Euphonium.* 1976. $21\frac{1}{4} \times 27\frac{1}{4}$ in. Limited edition of 100.

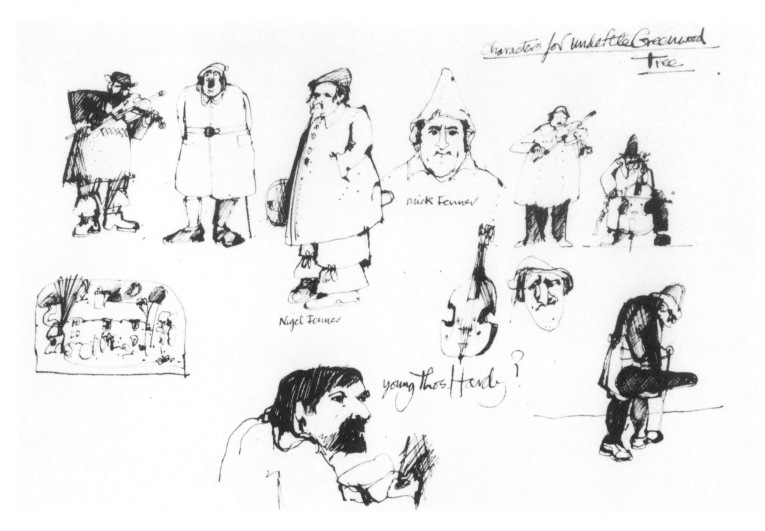

Characters for Under the Greenwood

mick Fenner

Nigel Fenner

young thos. Hardy?

22. Characters for *Under the
Greenwood Tree*. Sketchbook Vol. 4.

a deliberate and academic teacher. He was succeeded by Ronald Jewry, who
swept into the stuffy art studio like a breath of fresh air, painted it bright
yellow, and swept the class out with him on sketching parties. The boys were
encouraged to follow the free flow of their imaginations, to see and feel things
for themselves. 'Eccentric', some called it all, but Graham flourished in this
uninhibited atmosphere. He readily responded to Jewry's suggestion that the
class should copy their favourite masterpieces and that they should also paint
the subjects under their noses. Graham, who has never felt any enthusiasm
for the exalted offerings of art galleries, produced oil copies of Van Gogh's
Café Terrace at Night and *Harvest Landscape* from reproductions found in his
aunt's and uncle's house. He recorded his grandfather washing up and his
mother at her sewing-machine and, for his own 'education', tried his hand at
printing on an old Nipping Press that his Father had brought home from the
Midland Bank. Ronald Jewry remembers Graham as 'a very attentive pupil
with a wry sense of humour, studious but never dull'. Graham had a good eye,
he thought, and if copying had induced a strongly representational style,
Jewry was perceptive enough to detect 'an individuality and a poetic quality,
which I thought would emerge sooner or later'. Graham distinguished
himself in GCE 'O' Level Art but, in a reluctant attempt to get to grips with

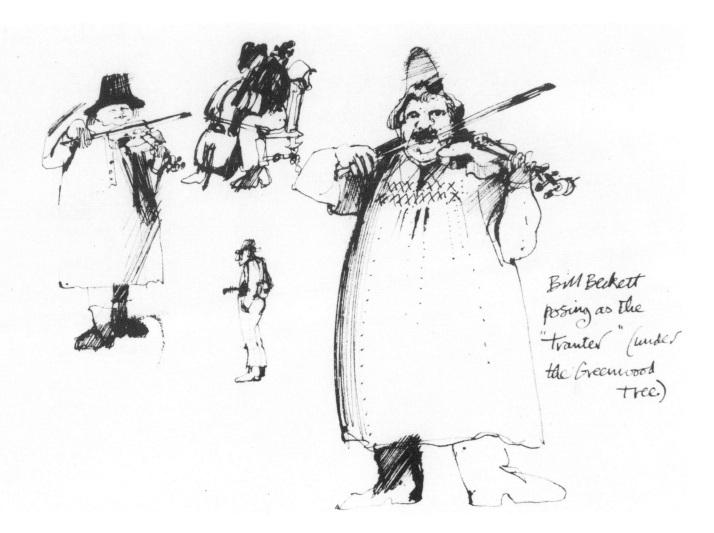

Bill Beckett
posing as the
"Tranter" (under
the Greenwood
tree.)

'O' Level Maths, entered the Science Sixth in the autumn of 1957. It was Ron Jewry who convinced Graham's father that his son should go to art school; he made the arrangement over the telephone with the Principal, John Cole, and Graham went along in the New Year and 'loved it'.

23. *Bill Beckett and Others.*
Sketchbook Vol. 4.

Lump of old Plasticine

Beckenham Art School in the late fifties was a small, closely knit society of some sixty to eighty students, and the family atmosphere suited Graham perfectly. He joined the two-year Intermediate Course and embarked on four exciting years which were to shape the distinctive marks of his idiomatic style. One of his most admired tutors, Wolf Cohen, found that Graham's cheeky self-confidence could be exasperating. 'He already appeared to know everything', Cohen recalls. Yet Graham describes himself at this period as 'a fairly pliant lump of old plasticine'. What is certain is that that 'lump' responded when it wanted to and, if it did not consciously respond to Modern Art, it certainly did to Samuel Palmer.

24. *The Goose Girl*. Dated on the right hand side, on the flag, 'JAN. 77'; published March 1977. Hand coloured in acrylic, $21\frac{1}{4} \times 27\frac{1}{4}$ in. Limited edition of 150.

This is the first time the artist used acrylic colour on etchings, which is more permanent than the coloured drawing inks he had employed previously. (See also p. 106.)

25. *Archipelago*. Dated bottom left, on the fishing boat sail, 'SEPT. 77'; published November 1977 by Christie's Contemporary Art. $21\frac{1}{4} \times 27\frac{1}{4}$ in. Limited edition of 200.

(See page 106.)

32

26. Sketchbooks

Since 1975 I've kept a continuous series of sketchbooks and am currently on Volume 14. Whenever time allows, I put in topographical watercolour sketches, ideas for new etchings and sundry odd visual notes.

I bind them myself using Green's 'Tovil' paper 'not surface', a very old gelatine-sized stock which has now almost run out. Although it's a printing paper rather than a watercolour paper, I like its dry, rather gritty surface. The page size of my books is 6 × 9 in., and each book has nearly a hundred pages. Usually I work on the right side only as, inevitably, there is a certain amount of 'show through' when using pen and watercolour on a thinnish paper.

I always cover the books in a piece of cloth from Wendy's rag-bag—old shirts, dresses, jeans, curtains, etc. And I marble the endpapers. They're not very expertly bound but seem to stand up to almost constant use as my main source of reference, and as a record of our 'jaunts'.

Graham has observed that 'the great turning points in one's development relate to something you learn from a teacher, read in a book or see in a picture, but they are usually things already half known. The truth is there, hidden, but it may be revealed by a composer, a painter or a writer. I expect I already half knew about the spirit of Palmer and his imagery, and I just needed to see it to take a step forward.' The discovery was prompted by George Fry's History of Art course: Graham took the short train journey out to Shoreham and visited the scenes of Palmer's visionary paintings and drawings. It was indeed a timely visit and the experience moved him deeply. The countryside around Shoreham seemed to epitomize that state of perfection which he himself was looking for in the world. His paintings burst with new impulses and colours. And there was a mood of harmony and serenity about them, a sense of being in close contact with nature, which corresponded to the feelings of spiritual elation he jotted down on one of his later visits:

Palmer loved this place and love it is that makes me walk here too.
Every lane is climbing up its hill [and] down again to the river, over the bridge and up and on again climbing & twisting.
These are not mountains here there is no raging torrent, the trees are not giants all is on a small scale, quiet & complete, Palmer decided God (and Nature) was at his best in this little valley of vision.
20 miles from London here is peace.

· ·

Palmer more than I saw God in what he saw but even I in this enchanted valley can see God in what I see, round hills, gentle farmers, thick coated

cattle quiet & contented in their winter quarters, . . . trees almost as round & perfect in their shape & variety as Palmer saw them.

These emotions were not just a sentimental surge of religious fervour in late adolescence. As a child, Graham and his brother attended Sunday School along with the other children in the neighbourhood, and happy echoes of favourite Bible stories and simple moralistic truths have reverberated in his imagination ever since. At eight he joined the Hayes Crusaders, a boys' group which bored him and which he tried to enliven by creating a small diversion with a mouse made from a folded handkerchief. The 'mouse' had been made to jump realistically enough to fool everybody, and Graham was put outside the door 'feeling highly satisfied'. At Park Langley Youth Club and, in his teens, at Bromley High Street Methodist Youth Club he found more welcoming audiences. He had always appreciated the company of people who like to be entertained, but the friendly, informal atmosphere and the charitable activities at the Methodist Club also offered him the emotional centre he was looking for. And it was here, in 1959, that he met the like-minded girl who was to become his wife, Wendy Hudd. Wendy, then fifteen, remembers that her first impression of Graham at a Club evening was entirely in character. Graham was scheduled to give an illustrated talk called 'Burlington Davis, 1827'. He started making a diagram on the blackboard, and as the drawing became more and more involved and slowly took shape, it gradually dawned on his half-amused, half-shocked audience that what he was at pains to describe were the workings of a water-closet. This talent for endowing a serious subject with a touch of humour was to be put to good use some time later, when he was commissioned to make cartoon drawings for architectural magazines. However, in the immediate months ahead, Wendy and Graham found themselves drawn together in the social organization of plays, pageants and parties. And, outside the Club, Graham involved Wendy in his craze for inexpensive curios, and bargain jumble with which he could earn a bow and a laugh in trend-setting outfits.

As a student, Graham is described by one member of staff as 'quiet and diligent'. But Wolf Cohen was concerned that Graham's extra-mural activities might distract him from his Diploma work. Graham recalls his tutor as 'small, fiercely energetic, and a model of dedication'. From Cohen he learnt that art could and should be life-absorbing, and he has lived by Cohen's example ever since. At the time, he was happiest working on a small scale, and his natural inclination was to relax into drawing funny characters in the long tradition of marginal 'drôleries', comic cuts and caricature. Cohen perceived the decorative nature of Graham's work and encouraged him to look at a wide range of ornamental detail, from runic stones and Polynesian carving to plant forms. Cohen then went on to introduce him to work by Dubuffet in which

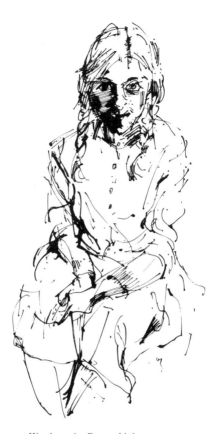

27. *Wendy*. 1961. Pen and ink, 14 × 10 in. Collection Wendy and Graham Clarke.

Drawing from the artist's sketchbook.

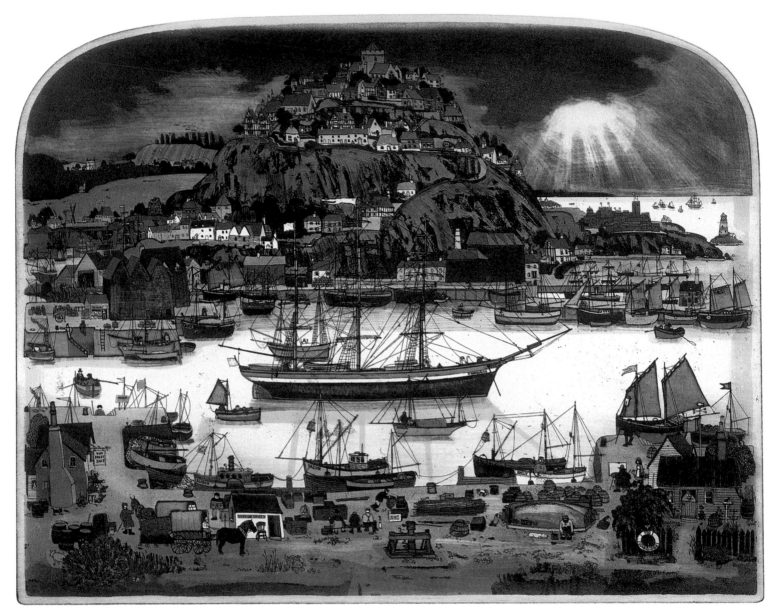

28. *Harbour*. 1976. $21\frac{1}{4} \times 27\frac{1}{4}$ in. Limited edition of 100.

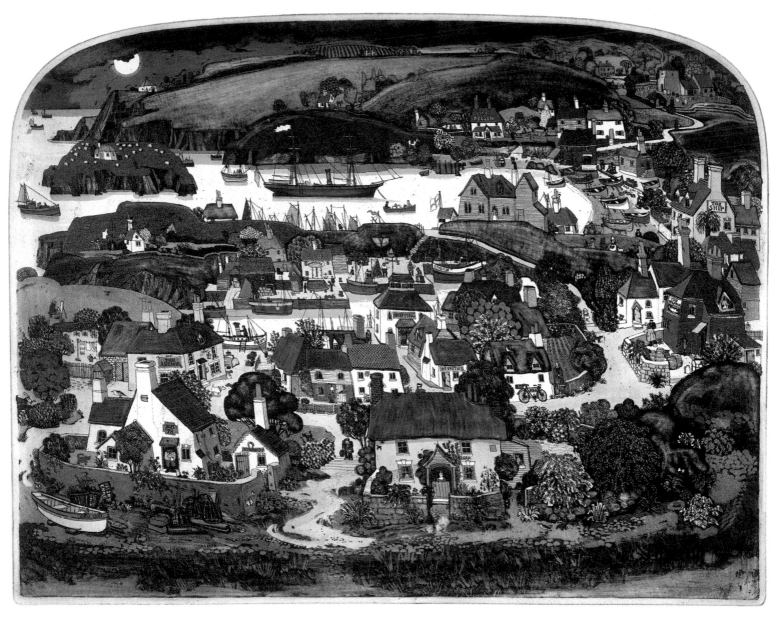

29 *The Sailor's Return*. Dated on cottage in left foreground 'SEPT '78'; published November 1978 by Christie's Contemporary Art. $21\frac{1}{4} \times 27\frac{1}{4} \times$ in. Printed on Barcham Green's hand-made Wealden paper in a limited edition of 200.

(See p. 107.)

30. *Self-portrait*. 1960. Black and white lithograph, 23 × 17½ in. No edition.

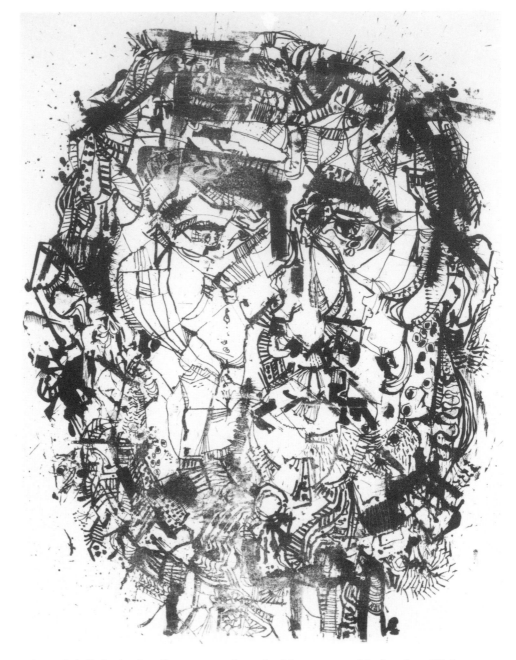

wit and delight in detail were employed with great sophistication. This was an enlightened move on Cohen's part and Graham's work grew bolder and more painterly. In this context, he encountered early icon painting and the work of Cimabue, and was attracted by the sometimes crude simplicity of these early artists' statements as well as by the devotion and care with which the objects were made. These were qualities he admired in pub signs, in children's samplers and drawings, in Bruegel and Van Gogh. He also responded to the formality and to what he describes as the 'theatrical quality' of the triptych form, whose doors seemed to open onto a small stage on which the religious drama could take place. Some large stylized heads in pen and ink, a self-portrait (Fig. 30) and a portrait of Chris Orr, one of Graham's contemporaries, show some of these influences at work. The images make no pretence at being realistic. They are pieces of pure two-dimensional fantasy,

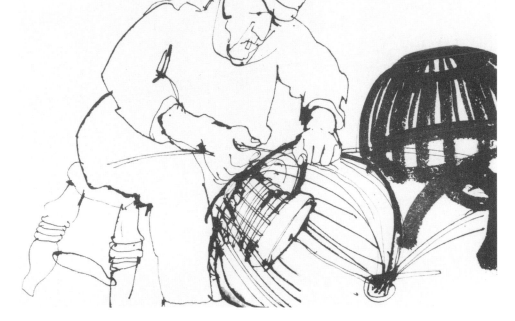

31. *Bob Brown*. Sketchbook Vol. 1.

Bob Brown, fisherman of Swanage, Dorset, is making a crab-pot on 10 April 1975. Born in 1902, he started work at the age of thirteen and was 'expected to do forty-eight hours' work without a break'. For twenty-five years he was coxswain of Swanage lifeboat but is now retired.

displaying considerable inventiveness and control over a riot of surface ornament.

Graham's actual figure drawing was unsure but it improved greatly in the life class which he attended regularly. This aspect of his work was also given encouragement by Susan Einzig, who spent the year 1959/60 teaching illustration at Beckenham. It was she who introduced the class to Laurie Lee's *Cider with Rosie*, which had just been published with illustrations by John Ward. Technically, the very fine pen-drawings had the sharp linear quality which Susan Einzig knew, from experience, to be essential for photographic reproduction, and Graham respected her professional attitude to the discipline of work. He was also drawn instinctively to Laurie Lee's autobiography. Its evocation of a rural life charmed him, and he has turned to it repeatedly, re-reading it several times a year since its publication. John Ward's delicate and sensitive drawings caught quite delightfully the fragile innocence of childhood. But it was the pages illustrating the kitchen, the centre and heart of the household, which seem to have exercised a particular hold over him. Here were all the ingredients of the home he knew he wanted: the old iron water-pump, the panelled and raftered interior, the cooking range, the plain wooden furniture, the candlesticks and oil-lamps, the jam-jars stuffed with cow parsley and wild flowers from the garden. Every corner and surface was awash with the tide of Mrs Lee's treasures, for 'Mother was a deliberate collector, and in this had an expert's eye', Laurie Lee tells us. And Mother had other special qualities which Graham may consciously or unconsciously have identified with: 'She was an artist, a light-giver, and an

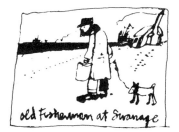

old fisherman at Swanage

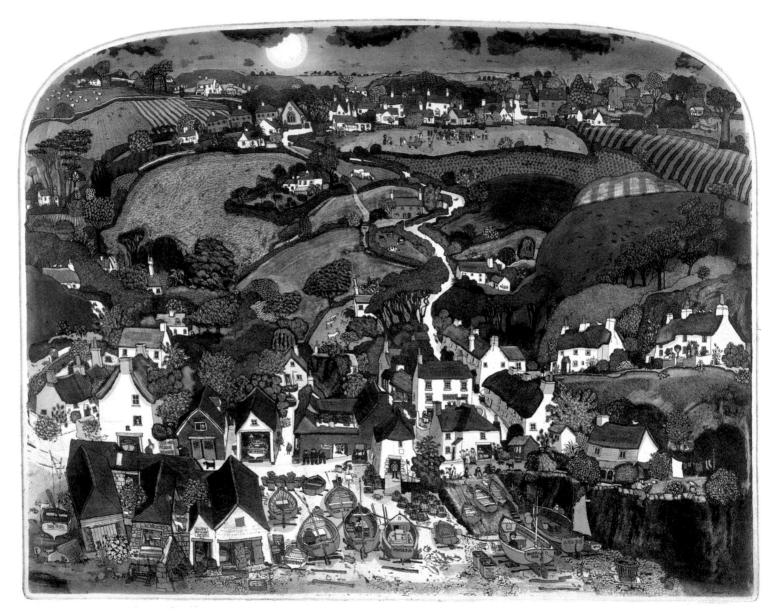

32. *The Nasty Tern*. Published November 1980 by Christie's Contemporary Art. $21\frac{1}{4} \times 27\frac{1}{4}$ in. Printed on Barcham Green's hand-made Wealden paper in a limited edition of 250.

(See p. 107.)

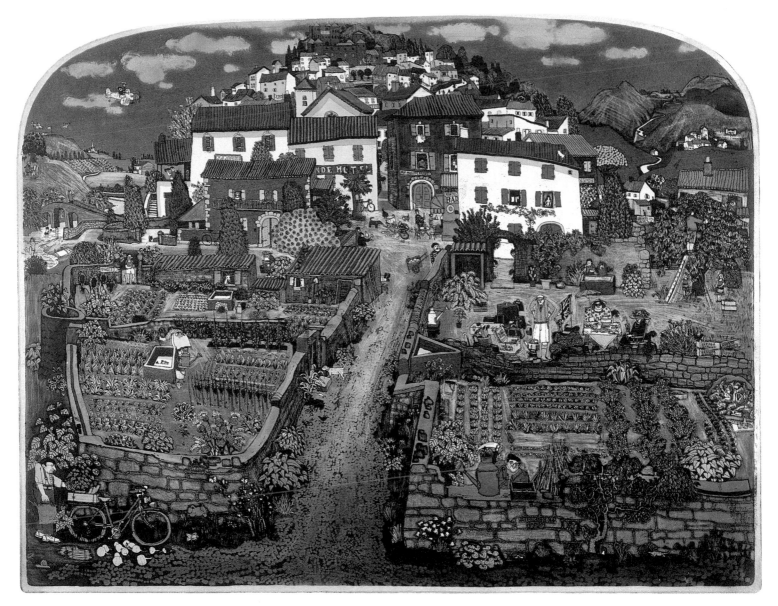

33. *Goût de Grenouille*. Dated on foreground wall 'November 1979'; published by Christie's Contemporary Art November 1979. $21\frac{1}{4} \times 27\frac{1}{4}$ in. Printed on Barcham Green's hand-made Wealden paper in a limited edition of 250.

(See p. 108.)

34. *Cottages at Chipstead*. 1966.
Etching on zinc, printed in sepia,
$9 \times 11\frac{3}{4}$ in.

This plate was made within a few
days of the artist receiving his first
instruction in etching from Wolf
Cohen. Printed in a very small
edition of signed but unnumbered
copies.

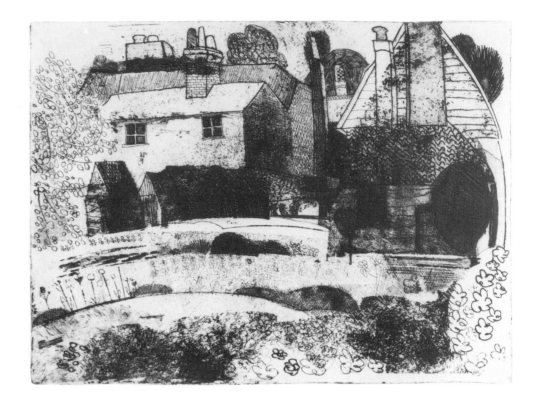

original, and she never for a moment knew it. . . .' Graham illustrated a
kitchen scene himself in pen and gouache. He made a lithograph of 'The
Twelve Days of Christmas', combining firm line and narrative detail, but the
main impact of John Ward's work was to be felt later.

In his final year at Beckenham, Graham was chivvied by Wolf Cohen into
setting his sights firmly on post-graduate work at The Royal College of Art.
Every year Cohen used to take six or seven of the livelier Diploma students
under his wing, spelling out the advantages of hard work. Graham
remembers spending Saturdays and sometimes whole weekends at Cohen's
studio working relentlessly to prepare his portfolio of work for the College.
He would be sent out to buy a steak to cook for their lunch, and then the work
would continue. Graham came to regard Cohen as the complete fulfilment of
his idea of what an artist ought to be, 'a total artist'. In William Morris, he
discovered an outlook which was even closer to his own ideals: the alliance of
fine art and craftsmanship, the emphasis on joy in the making, had immense
appeal for Graham. He found that print-making brought him closest to this
ideal, and he describes the long hours spent in this Department as some of the
most enjoyable of his whole time at Beckenham. The medium gave him the
physical pleasure of handling materials, grinding down the stone, applying
the ink, and getting his hands dirty, as well as opening up all kinds of aesthetic
possibilities (Fig. 34).

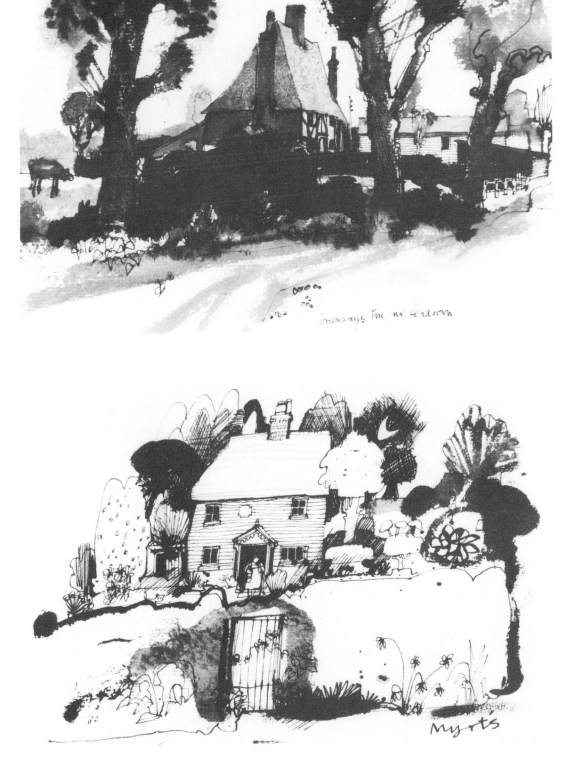

35. *Greenways Farm, near Headcorn, Kent.* Sketchbook Vol. 4.

36. *Myrt's.* Sketchbook Vol. 6.

Behind our house in a 'corner' of our garden, but separated by a very thick hedge, lived old Myrtle. Her cottage had no name or proper address and was known simply as 'up the Garden Cottage, Green Lane'.

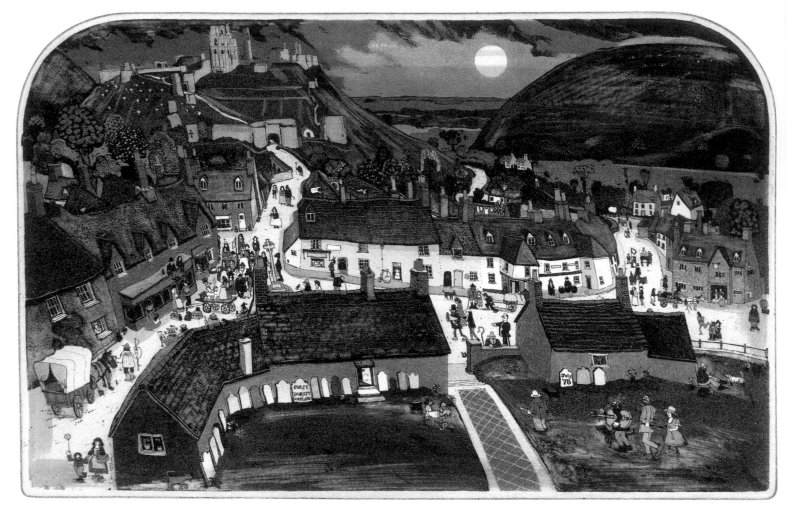

37. *Corfe Castle*. Dated on gravestone in the churchyard ''78'; published July 1978. $13\frac{1}{2} \times 21\frac{1}{4}$ in. Limited edition of 250.
Based on drawings done from the tower of Corfe Castle parish church, Dorset.

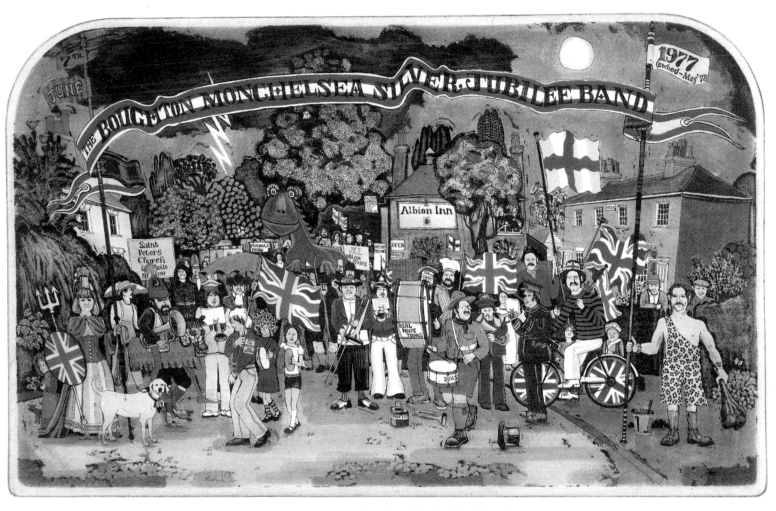

38. *Left Right, oops!* Dated on the flag 'May '78'; published June 1978. $13\frac{1}{2} \times 21\frac{1}{4}$ in. Limited edition of 250.

(See p. 108.)

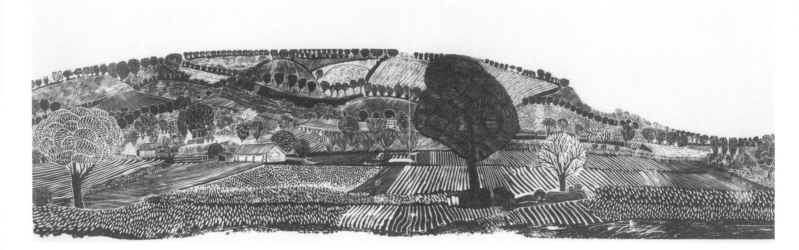

39. *Shoreham, Kent.* 1964.
Woodcut, 12 × 48 in. Cut on a plank
of lime wood given to the artist by
Edward Bawden. Handprinted by
spoon burnishing, in a small edition
of signed but unnumbered copies.

When Graham arrived at the Royal College in 1961, he was suddenly deprived of his new-found joy because, under Anthony Froshaug, he was set to design car dashboards and dials and 'digital fidgets of all kinds'. He felt out of his element. Added to which, his country bumpkin figure, clad in a ginger-coloured Harris tweed suit, stood ill at ease with the American College look and the basket-ball shoes. There was the question of subject matter too. While Graham sought his imagery in the countryside and in historical sources, most of his contemporaries were flicking through American motor-cycle magazines or perusing photographs of pop stars. People looked askance at his pen and ink scenario of a country market in Essex and he felt that he had, as he said, 'to plough a lone furrow'. 'I didn't feel a hero', he recollects. 'This was all I could do with sincerity and I didn't feel the need to ride another horse.' This dogged determination to plough his own furrow could have been interpreted as inability or stubbornness, and the outcome might have been disastrous for Graham's career had it not been for the understanding approach of Richard Guyatt, who was then Head of Department.

It was certainly a disheartening year for Graham, a period which he now describes as 'a dark tunnel with a light at the end of it'. Wendy and her family were very supportive throughout this time. It was a relief to be able to relax with them and to listen to Wendy's father spinning out his ceaselessly funny anecdotes. And so with their cheerful understanding, and the sympathetic tutorship of Brian Robb, Graham slowly regained his confidence. Wolf Cohen, to whom Graham had again turned for advice, suggested that he approach Edward Bawden, a part-time tutor at the College. Graham admired Bawden's work and was equally moved by the man himself—by his gentleness and kindness, and by his manifest love of materials. Their

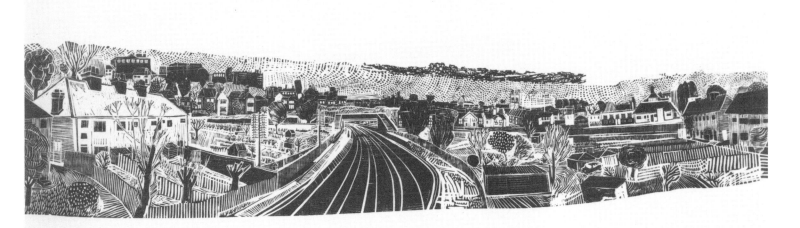

conversation on the few occasions when he met Bawden was mainly restricted to technical advice about tools and resources, and an early incident gave Graham a new direction. Bawden handed Graham some large planks of lime wood, which inspired him to work boldly and to produce a continuous stretch of Shoreham landscape (Fig. 39). Once back at home, he cut some miniature views of Bromley, which Bawden 'was kind enough to mistake for wood engravings'.

Graham's interest in the early history of his home town was emerging strongly in the early sixties and, when he and Wendy were able to buy a place of their own, it was a little two-up two-down Victorian artisan's cottage at 77 Palace Road (Fig. 6). At the time, Graham was preparing a third-year project entitled 'Social Aspects of Bromley', and it is clear from the notes he made a year later, in 1965, that his interest did not lie in local history, vernacular architecture or contemporary anecdote for their own sake. His main concern was that 'the Bromley of our fathers & grandfathers is being removed quietly and quickly'. So he went out photographing this older Bromley, its narrow lanes, pubs, small old-fashioned general stores and family grocers, a bespoke shoemaker, an old pump, millworkers' cottages and an eighteenth-century classical building, Bromley Lodge, home of the Conservative Club. But fine architecture and the way of life it reflected have never caught his romantic imagination in the way that humbler buildings and quaint byways do. Many of these vanishing corners of old Bromley are recorded in pen sketches, with historical annotations. Some may have been sketched on the spot, others worked up from the photographs. In either case it is interesting to compare the two, and to note what caught his eye—the decorative texture of tiled roofs, the rickety look of old cottages, details of chimney-pots and drain-pipes with their twists and turns and excrescences—and what he chose to ignore.

40. *Bromley South.* 1963. Woodcut, $11 \times 48\frac{1}{2}$ in. Cut on a plank of lime wood given to the artist by Edward Bawden. Handprinted by spoon burnishing, in a small edition of signed but unnumbered copies.

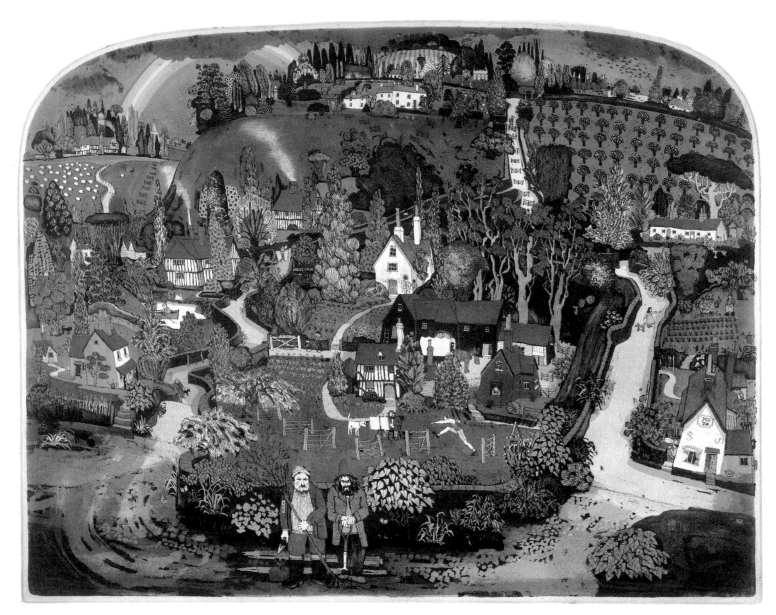

41. *Teapot Clipper*. 1980. 21¼ × 27¼ in. Limited edition of 250.

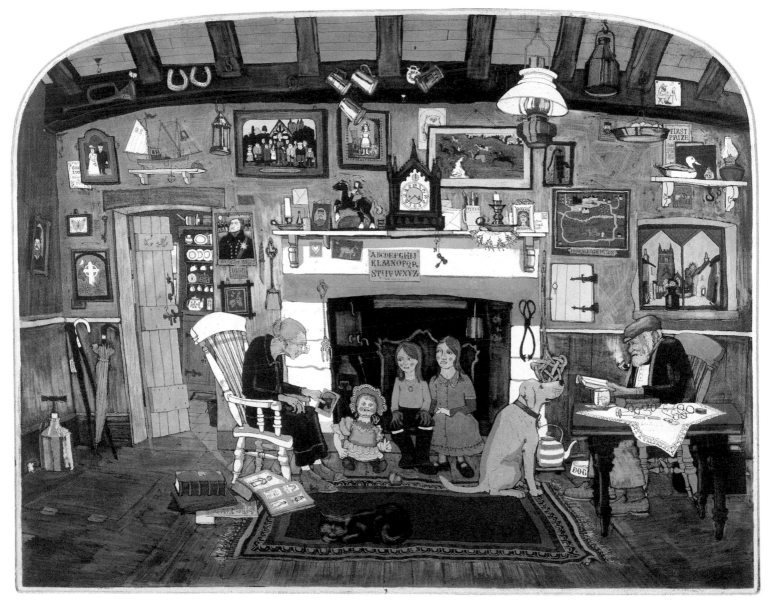

42. *Nethercott*. Published June 1981 by Christie's Contemporary Art. 21¼ × 27¼ in. Printed on Barcham Green's hand-made Wealden paper in a limited edition of 300.

(See p. 108.)

He has kept the pattern of the railway lines but edited out the high-rise building on the horizon, the modern cars, the crane and the advertising messages. He had added an old street-lamp and a tradesman's van and quickened the trees into spring-time bud.

He was also taking his camera out into winter-time Shoreham, appreciating the arrangement of thorns, peering into tangles of branches and searching for 'significant' trees with a poetic eye. But the lino prints and block prints, which he started making in his last year at The Royal College, evince a sturdier sensibility, charged by elemental things, by earth and clay, wood and stone. Boats and animals, views of Shoreham and the Kentish landscape, with their ploughed fields, stripy hills, small farmhouses, suns and moons, all reflect the dark tones, the purples and sepias of Palmer's visionary landscapes. They also reveal the hand of the craftsman at work in the remarkable way in which they lay bare the structure of landscape, and the structure of boats. Only a man intimate with boats could so clearly define the curve of a hull, built from stout planks, in two-dimensional terms. With Brian Robb's guidance, Graham transferred some of the rich effects he had achieved with the textures of fabric and woodgrain to the more painterly medium of ink and varnish. The seductiveness of these images is unquestionable, and Michael F. Levey, then Creative Head of Publicity for London Transport, remembers

43. Preparatory drawings and notes for *Miss Wirtle's Revenge,* later titled *Nethercott.* Sketchbook Vol. 11.

My first thoughts for illustrating Michael Morpurgo's long poem, *Miss Wirtle's Revenge.* I made this drawing sitting at his kitchen table in Iddesleigh, North Devon. *Nethercott* is the name I gave to my large etching. The same evening I met another poet, a friend of the Morpurgos, at the pub—Ted Hughes, now Poet Laureate. A very nice man—we talked about fishing.

Sketch for Miss Wirtles Revenge.

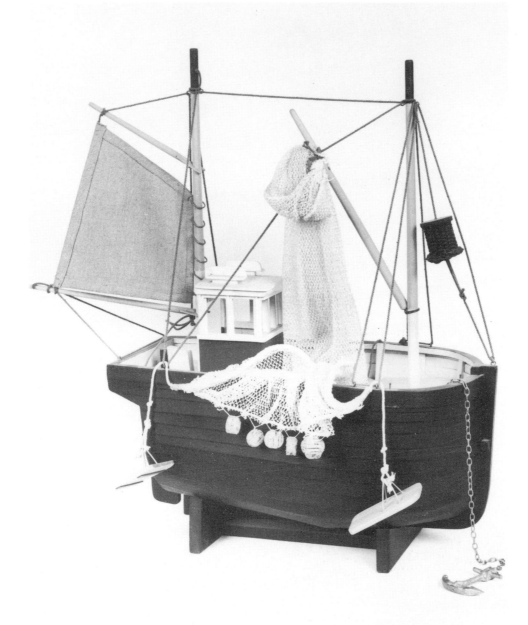

44. Fishing Boats. An edition of 25 'Coarse Models' in wood. Numbered and signed on brass plate on stern. Each vessel has a different name on the transom, and each one is painted in a different all-over colour scheme. Size: height 28 in., length including jib 27 in., beam 11½ in.

While on a visit to Rye, I greatly admired what John Owen called his 'coarse models', free and rugged interpretations of sailing craft owing little to accuracy or finesse but full of spirit. A year or two later Jason, then about ten years old, and I, being at a loose end on a Sunday morning, set about making our own. Alex Gerrard saw the result and encouraged us to produce a fleet (edition) of them. This was done with the skilled assistance of several craftsmen friends working to my original, including John Soudain who so beautifully made the 'real' trawl nets.

how impressed he was with the work: 'It was entirely idiosyncratic. Its strength and colour made it ideal for poster purposes in the street and Underground environments where designs simply have to stand up for themselves. On the other hand, equally valuable, his details and textures meant you could go back to these drawings again and again.' Kenneth Clark was to respond in a very similar vein when he praised one of Graham's etchings for its persuasive power in drawing the viewer to look both at and into the image. With London Transport's continuing reputation for commissioning established artists as well as for discovering new talent, Graham felt he had 'arrived'. His poster *Knole* (Fig. 10) was published in 1967, followed by *Chenies* (1969), *Richmond* (1972) and *Christopher Wren* (1973). The relationship was a fruitful one, Michael Levey recalls, not least because of Graham's businesslike co-operation: 'With the very strongest

45. *Scene from an Unwritten Book.* 1974. 13½ × 10½ in. Limited edition of 100.

46. *The Loaves*. 1979. 13½ × 10½ in. Limited edition of 250.

Illustrating the 'Life-cycle of a loaf of bread'.

opinions and beliefs of his own, he would always listen, always discern which matters were his and which ours.' The block print of Llanthony Priory in Wales (Fig. 9), which Graham completed for Shell in 1967, marked another important collaboration with a highly respected patron.

New Horizons

In the years after leaving College Graham and Wendy were mainly preoccupied with ways of making ends meet. They had married in 1964, and their son Jason was born the following year. On the strength of his Post-Graduate Show, Graham was offered a teaching post at Canterbury College of Art. At the same time, he accepted a useful commission which set another pattern of future development: he was asked to illustrate language courses. Graham had never been short of cartoon jokes for friends, but figures only entered the paintings incidentally, and were never included in his block prints. But now, with a very specific brief, he had to take his penchant for humorous character drawing seriously. A year later, in 1966, Graham fell into partnership with two graphic designers, Collis Clements and Edward Hughes (the latter best known for his stamp designs to celebrate the wedding of Princess Anne and Mark Phillips, and the centenary of Churchill's birth). This time a chorus-line of ladies with mops, and ever-ready helpful hopefuls, ran off Graham's inspired pen to brighten up the promotion material for the London Agency, 'Problem'.

Graham's meeting with Edward Hughes at Canterbury College was propitious. When he and Wendy visited the Hughes socially at their Late Victorian house among Kentish orchards, they found both a style of life which answered their own dreams and an approach to life which promised new horizons. Ted Hughes combined teaching and commercial work. But there he was at home, burnishing his own wood blocks with a spoon and printing them entirely by hand. Graham realized that he need not be limited by conventional career-lines either. He, too, could enjoy the pleasures of the fine artist. Moreover print-making seemed to provide an answer to the dilemma of making fine art productions, selling them, and yet being able to retain an original. He began to look round for a hand press and remembered seeing an old machine in the shed of a neighbour, also a printer. It was loaned with the verbal agreement that Graham would give him £40 if it turned out to be what he wanted. It was. The printing press proved to be a Cogger of around 1820, and is thought to be the only one of its kind in operation. Fortuitously, Joe Studholme, a founding Director of Editions Alecto, expressed interest in Graham's block prints with their strong design and

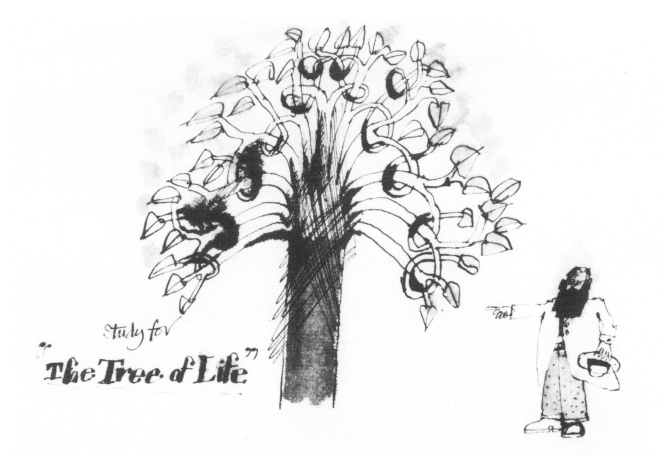

"Study for "The Tree of Life""

serenity of mood. Alecto had been set up in 1962 and had enjoyed a remarkable success with a galaxy of names, among them David Hockney, Eduardo Paolozzi and Richard Hamilton, as well as Edward Bawden and Gertrude Hermes. Now they wanted to widen their range of artists and commissioned a print edition of twelve of Graham's Shoreham landscapes. And so, in the summer of 1965, he and his young apprentice David Birtwhistle started printing *Cottage in a Valley* (Fig. 13), the first of their limited edition prints for Alecto. The imprint they chose was suggested by Graham's discovery that the original name for their Victorian terrace in Palace Road was 'Ebenezer Cottages'. The name was suitably Dickensian, and Ebenezer Press was established in 1966. In 1967 and 1969, Graham was to accept another two successful commissions from Alecto, this time for sets of eight prints based on fishing boats at Rye and Hastings.

With his teaching at Canterbury, and, later, at Maidstone College of Art, his various commissions and a small, regular, monthly sum from Alecto, Graham could feel he was establishing roots as a professional artist. So far his themes were a continuation of those evolved at The Royal College, and he

47. Study for *The Tree of Life*. Sketchbook Vol. 6.

Please don't ask me to explain.

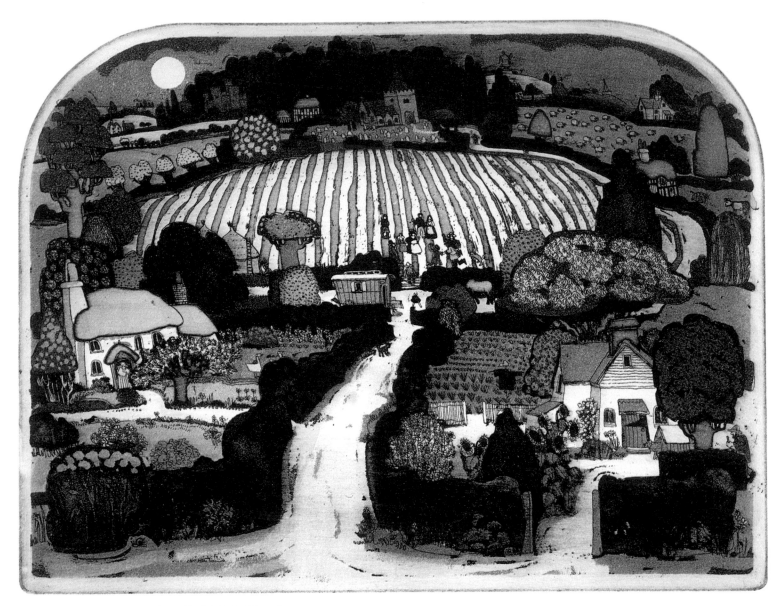

48. *Sunflowers*. 1976. 10½ × 13½ in. Limited edition of 100.

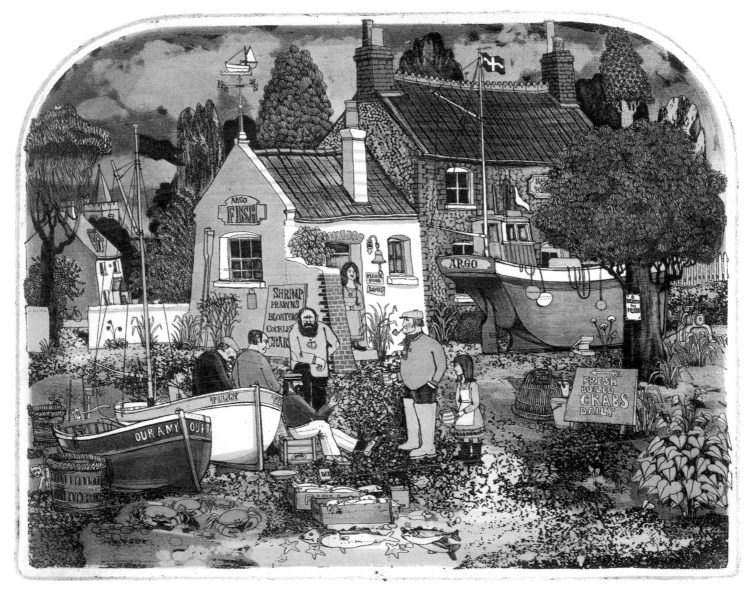

49. *Tilly's*. Dated on tree '1?82'; published 1982. 10½ × 13½ in. Limited edition of 300.

Based on fishermen's cottages in north Norfolk, drawn on a visit to Alfred Cohen in February the same year.

50. *Garlon.* Sheet No. 9 from the artist's handprinted book, *Balyn and Balan.* 21 × 14¼ in. One of 16 folio sheets between boards surfaced with English woods. Published in a limited edition of 100 copies by Ebenezer Press, Boughton Monchelsea, 1969.

The narrative was taken from *King Arthur and the Knights of the Round Table* by Roger Lancelyn Green. The pages of text were cut by hand from planks obtained from the wood of a single apple tree.

began to plan the next creative stage of his career. The idea came to him while sitting in hospital in the early hours of the morning, awaiting Jason's birth, and reading the Arthurian legend of Balyn and Balan in Roger Lancelyn Green's *King Arthur and His Knights of the Round Table*. And the plan quickly took shape for a *livre d'artiste* which he could publish himself at Ebenezer Press and which would revive the pleasure of lettering—a pleasure he had first discovered through his calligraphy tutor at Beckenham, Miriam Stribley. He bought an apple tree and started cutting the text for *Balyn and Balan* (Figs. 50 and 51), section by section, out of its sawn planks. Wendy and their friends well remember Graham's curses and cries of frustration as he

51. *The Other Knight*. Sheet No. 15 from the artist's handprinted book, *Balyn and Balan*.

See Fig. 50.

inadvertently cut the cross bar off a 'T' or the side out of an 'O'. Everyone would be down on their hands and knees searching for the minute chip of wood. Despite these setbacks, Graham was too caught up in the infectious enthusiasm for Ben Shahn's folk alphabets to abandon his plan. The capitals he designed were chunky and unschooled, and allowed the tale to emerge in rugged, heaving lines. As his friend the poet John Birtwhistle says: 'Anything of perfect regularity would be anathema to Graham, who would always prefer a regular irregularity, and to see the personal marks of a craftsman.' Cutting the text and illustrations was clearly going to occupy many months; there was other work to be done and, meanwhile, a second child, Abigail, was born in

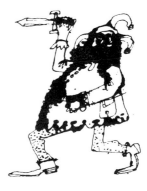

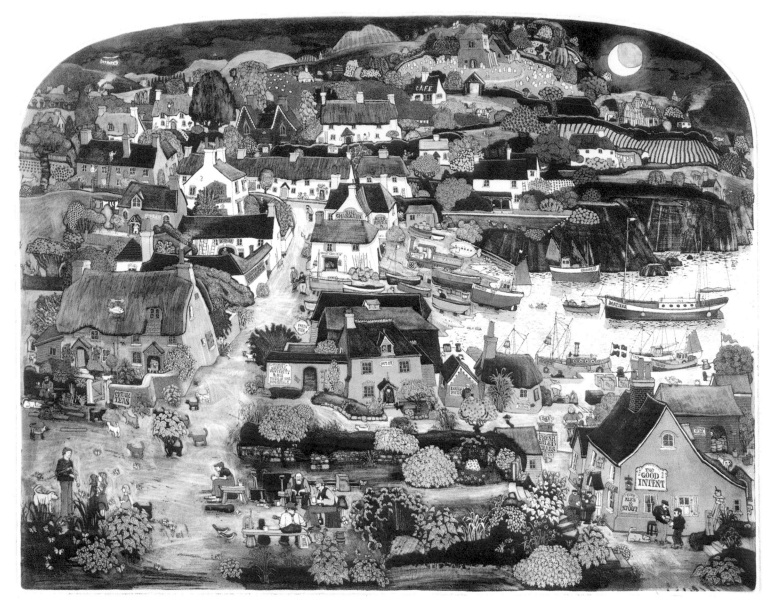

52. *Uncle Sid & the Limpet Racers.* Dated on central cottage 'OCT. 82'; published October 1982. 21¼ × 27¼ in. Limited edition of 300.
(See p. 109.)

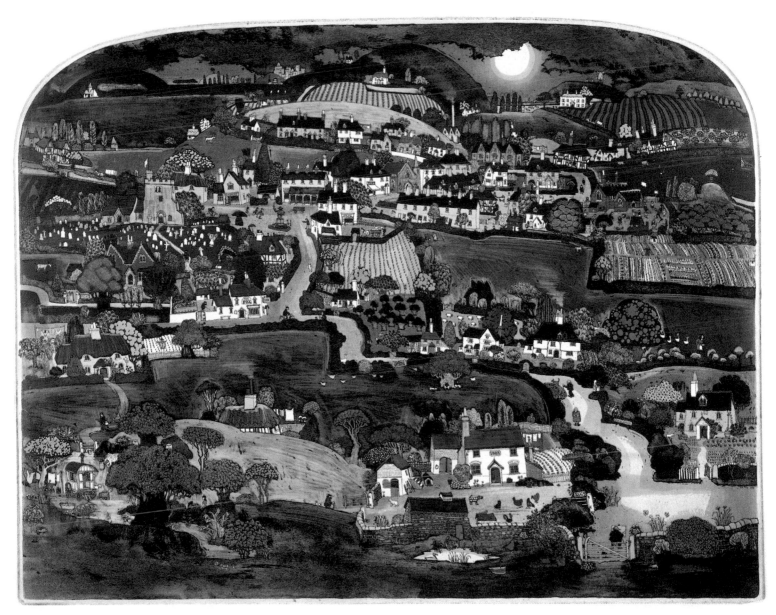

53. *Garlec Arkham*. Dated on farm in foreground '1983'; published 1983 by Christie's Contemporary Art. $21\frac{1}{4} \times 27\frac{1}{4}$ in. Printed on Barcham Green's hand-made Wealden paper in a limited edition of 300.

The title *Garlec Arkham* is an anagram of 'Graham Clarke', who likes garlic, French cooking and making pictures of arks.

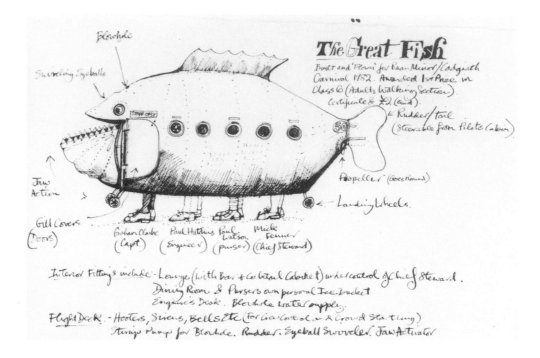

March 1968. The house in Bromley was already cramped and the family moved in the summer to Boughton Monchelsea, to a dilapidated cottage, with a massive timber frame, dating back to the 1380s. Graham was kept very busy making the house habitable enough to satisfy the building inspector, but found time to print and publish the first copies of *Balyn and Balan* in 1969 as a folio of sixteen consecutive sheets between covers surfaced in English woods. The design of the cover, as Kenneth Clark remarked, 'puts one in the right frame of mind for the contents'. And he wrote enthusiastically in praise of the book: 'The first thing I like about it is that it is so uncompromisingly non-utilitarian. It is a glorious protest against everything that is practical, economical, useful. It is a Ruskinian book in the best sense.'

Graham was not immediately clear where this incursion into fine book production would lead him. He was finding the medium of block printing increasingly limiting. While it met his desire to convey a mood of rustic simplicity, it failed to effect the refinement and complexity of detail he had been working towards at college. He was now looking both for an intellectual way forward and for a medium that would satisfy him. In 1968, Wolf Cohen gave him the briefest instructions in etching, and some zinc plates, and Graham went home to experiment. Some time later, when he was settled in his new house and had a larger studio, Cohen also helped Graham to buy an etching press. The medium took several years to master on his own, but Graham thoroughly enjoyed the line and texture he could achieve and began to think about ways in which his new skill could make another distinctive

Etching No 4 Size

Castle
Churchyard
Hens Hut
V. Small Fishing Boats in Distance
Great Variety of Trees
Sheep Cattle
 Self Sufficient Island
Fishermen Children
Flags
Date on Boat Registration
Crabpots

Harbour
Shop Huts Pub, Cottage
Washing on Line

Boats as in Lottie & out

54. *St George's Bicycle.* 1981.
$10\frac{1}{2} \times 13\frac{1}{2}$ in.
Limited edition of 250.

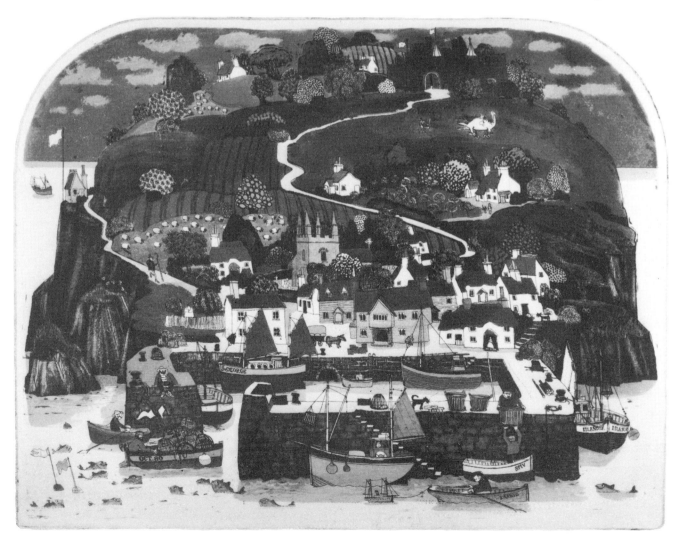

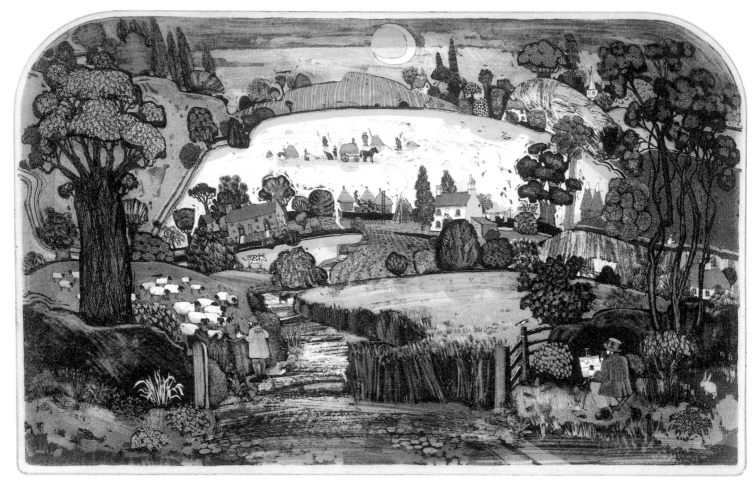

55. *Song of Samuel.* November 1978. $13\frac{1}{2} \times 21\frac{1}{4}$ in.

This etching was donated by the artist in support of the campaign mounted by the Council for the Protection of Rural England and The Shoreham Society against the proposal to drive the M25 Motorway across the North Downs. In particular, the Motorway would have destroyed Upper Timberden valley at Shepherd's Barn, immortalized in the visionary paintings made by Samuel Palmer during his stay in Shoreham between 1827 and 1832, and pictured here by the artist. The figure at his easel in the right foreground is Samuel Palmer.

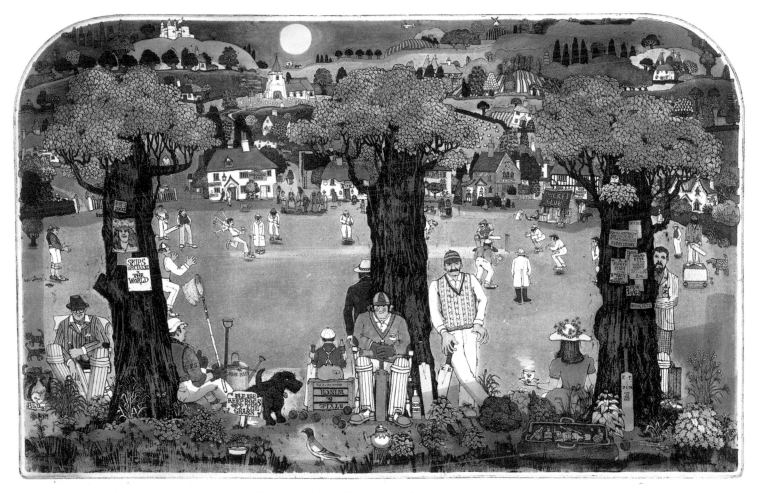

56. *Quite Cricket*. Dated on tree 'DEC 1983'; published 1983. $13\frac{1}{2} \times 21\frac{1}{4}$ in. Limited edition of 400.

'A bespoke picture especially nagged for by D. Attwood (Gent.) the Wootton Wooleys and young Alex.
 "When are you going to do a cricket print?" They said.
 "Never." I said — so here it is.'

(See also p. 109.)

contribution to the art of the book. He had already adapted an existing text, and the next most logical step was to illustrate an original piece of writing.

Graham chose a historic subject with local connections, Wat Tyler, leader of the Peasants' Revolt of 1381, and commissioned John Birtwhistle to write a long narrative poem. The project was an overwhelmingly ambitious enterprise, and it took John Birtwhistle many months to amass the material and find a suitably robust verse form. Finally, he decided to write in crude, almost doggerel-like couplets which he felt would reflect the harsh nature of the narrative. Together they agreed the content of each section of the story, and John Birtwhistle suggested that each main plate should be crowned by a 'reigning emblem', to which Graham was to lend additional significance by placing it within an arched frame.

While Graham showed some interest in the political implications of the Peasants' Revolt, he found himself reflecting more and more deeply on the ways in which the event related to his village and its inhabitants, and imagining what life was like for the people who were born and grew up in his own cottage in Plantagenet times and after. The joy surrounding the birth of his third child, Emily, in 1972, gave added meaning to these thoughts and to the final image in the book. This plate, with its vision of the future, encapsulated Graham's view that, given a happy environment, everyone could be happy.

Dance by the Light of the Moon

The rural scenes in the *Vision of Wat Tyler* (Fig. 57) gave such particular pleasure to their many admirers that Graham thought of printing the landscapes as single images, shaping the top of the plate into the distinctive curve that has since become his hallmark. The first of these so-called 'arched top' etchings, *Dance by the Light of the Moon* (Fig. 16), was exhibited at the Royal Academy Summer Show of 1973 and, from its 'forty-two red spots', was clearly attracting so many buyers that David Case, a Director of Christie's Contemporary Art, immediately approached Graham to initiate a business arrangement which is still flourishing today. Graham Clarke is now one of their best-selling printmakers. He adds six or eight new images each year to Christie's catalogue and has undertaken three special commissions to illustrate a property for their National Trust Collection.

As Graham's friend and former colleague Ted Hughes has said of Graham's joy in etching: 'the medium made the man'. It can also be said that the medium embodies the man, for the images that have come off Graham's etching plates have released a complete expression of his personality. In his teens he was an inveterate jumble saler, on the look out for objects which were

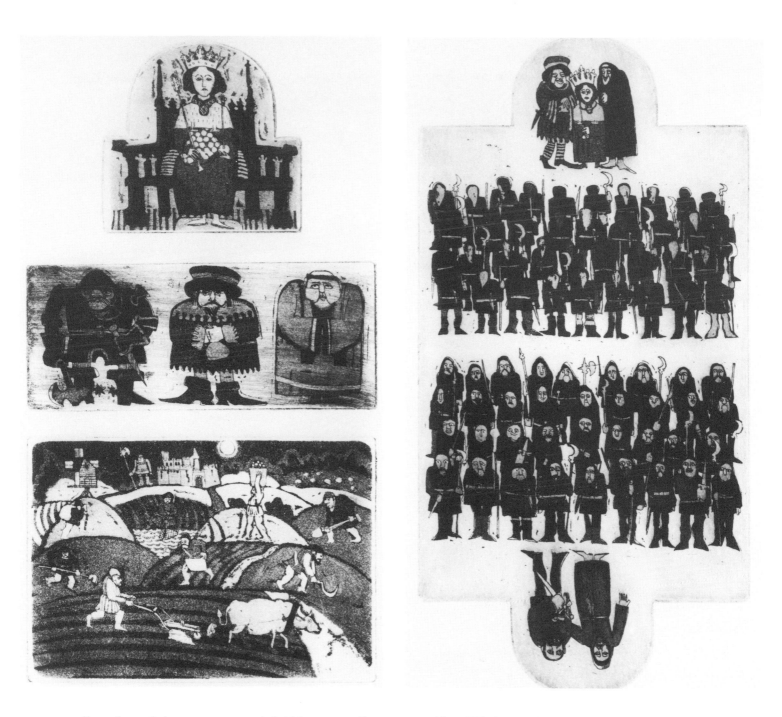

well made and time-worn—an inlaid box or a silver sugar-sifter. His house in Palace Road was furnished with old-fashioned tables and plain wooden chairs and benches. Friends were encouraged to dress up for shoestring entertainment: 'Victorian Suppers for Distressed Gentlefolk' and 'Carbohydrate Parties' at which potatoes in their jackets, bread pudding and cider were served. Musical *divertimenti* on an assortment of musical instruments were always part of the fun. And the fun continued at Boughton Monchelsea and, later, in Cornwall, when Graham and Wendy bought a cottage on the Lizard Peninsula in 1976. Indeed, wherever Graham goes, he carries his pack of work, his energy and his enthusiasm along with him. He continues the tradition both of journeyman craftsman and of travelling entertainer. He can satisfy nostalgia for the good times and the good people of long ago with the

57. Etched illustration from Sheet No. 2 of *Vision of Wat Tyler.* Handprinted book, 24 × 11½ in. Composed of 16 'triple' folios between reverse hide covers made by Bert Seth of Staplehurst. With etchings and calligraphy by the artist. Original poem by John Birtwhistle. The whole book was printed in 16 different 'brown' inks on De Wint hand-made paper, specially 'hot' pressed by Barcham Green and Co.

58. Etched illustration from Sheet No. 10 of *Vision of Wat Tyler.*

See Fig. 57.

59a. *Open Beach* 1. Sketchbook Vol. 3. Constable used to make a good job of this sort of thing in his little oil sketches.

59b. *Dungeness Looking North*. Sketchbook Vol. 2.

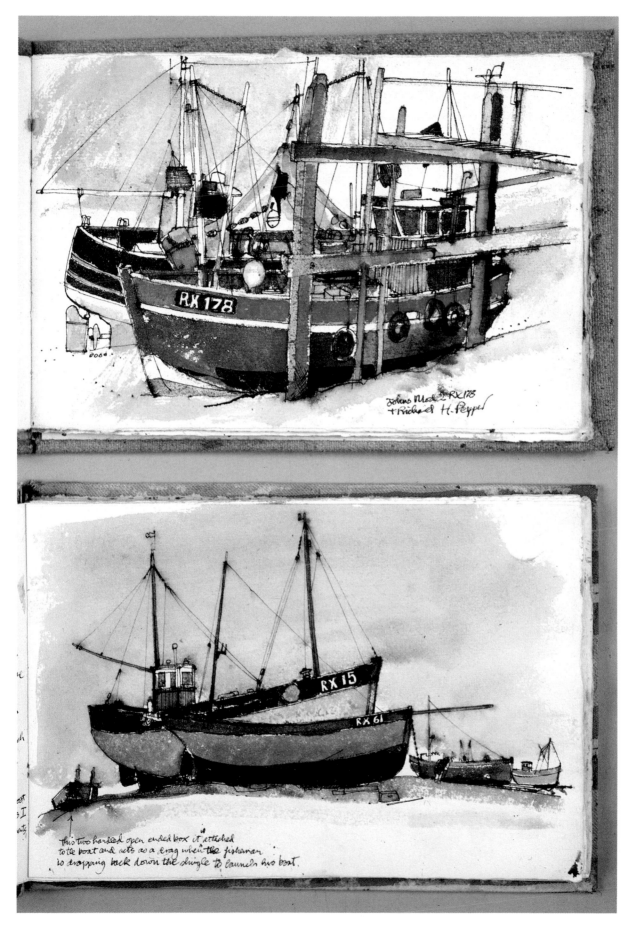

60a. *John's Model and Richard H. Pepper*. Sketchbook Vol. 5. Two luggers (trawlers) on the mud at the fishmarket, Rye.

60b. *RX15 RX 61*. Sketchbook Vol. 1. Two nice boats at Hastings. (RX Port of Rye.)

good times of today, with early music concerts and carnival, pantomime parties and play-acting, and with universal good humour in celebration of the ordinary working life. And it all finds its way into the etching.

The delicacy of the medium allows Graham to catch the spirit of the past in the spirit of life around him in all its humorous detail. He has explained that when he has found his subject, it opens a door and he can go inside and walk round. He then draws the walk in mono-line and lists the main 'ingredients', as he calls them. All these ingredients are then incorporated in the etching, together with many of the thoughts that are going through his mind at the time. When he was making *Notte Todaye* (Fig. 84), he remembered that the vicar had refused permission to climb the church spire to get an overview of

61. 'Gastaphone'. A strictly limited edition of one, 'Coarse Instrument' made of wood, cast iron, copper, brass etc. etc. Size: height 69¼ in., length 47 in., width 20⁷⁄₁₆ in. September, 1984. World Premier performance, Christie's Contemporary Art, London, December 1984, accompanied by 'Plastered in Paris'.

Alternative tricknoledgy's answer to the fast-breeder miniature electronic keyboard, so prevalent in music shops of late. There is nothing they can make in Japan that this instrument can't do larger or worse. It even has a built-in calculator.

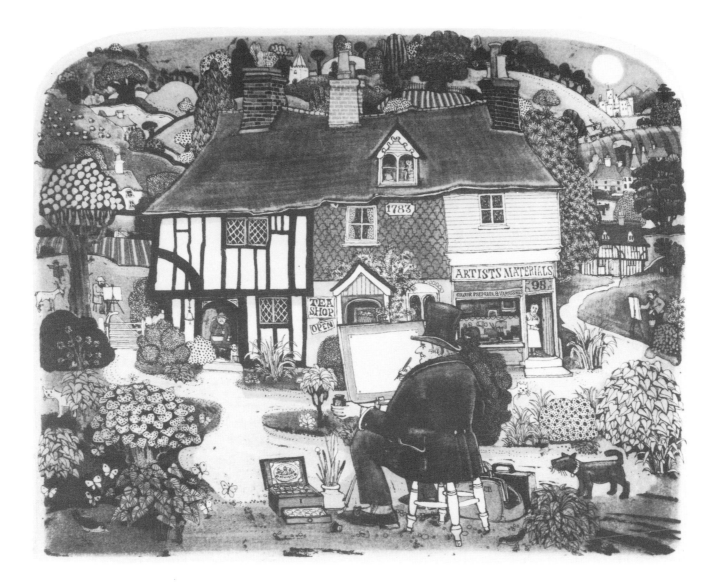

Stokesay Castle. Graham's only comment was to turn the vicar with his back to us. Then his grandmother died while he was at work and, as he could not attend the funeral, he added a gravestone to the picture in her memory. The inclusion of himself, painting at his easel, or of himself as a yokel or village musician, and of members of his family is now so automatic that if you ask Graham, 'Is Wendy there?' he will probably reply 'Oh, I expect so' or 'She must be'. Sometimes members of the family will pop up several times on a large plate. When Tilly, Graham's third and youngest daughter, saw herself coming out of one of the castle doorways in *Notte Todaye*, she was delighted and said, 'Am I going to play in the builders' sand?' And Graham's immediate thought was: 'Yes, she jolly well ought to.' So he drew her in again, with her spade. To be able to please people in this way is one of his greatest joys in the medium: 'If someone wants to be included, I put them in just to please them. If they notice the lack of an aeroplane or if they want their car included, for example, I'll probably put those in, too, to please them. But, I agree, mine are rather old-fashioned examples.' The discovery of the medium has allowed

62. *By Appointment*. Dated on cottage in centre '1783'; published March 1983 to celebrate the 200th anniversary of the establishment of George Rowney & Co., maker of Artists' Materials. $6\frac{7}{8} \times 8\frac{1}{4}$ in. Limited edition of 300, of which half were distributed by Rowney to 'Special Customers'.

The figure working at his easel in the foreground is J. M. W. Turner. The (real) artist is painting in a field on the left-hand side of the picture.

63a. *Stone in Oxney*. Sketchbook Vol. 4.

63b. *Boxley Church*, near Maidstone, Kent. Sketchbook Vol. 2.

64a. *Barming*, Kent. Sketchbook Vol. 2. Well away from the village in the Medway valley, a few miles upstream from Maidstone.

64b. *Grade Church*. Sketchbook Vol. 5. A fine old granite church on the Lizard Peninsular in Cornwall, we can see it from our cottage and so can the fishermen out at sea. They make use of it as a landmark and as a subject for mysterious stories of the old times.

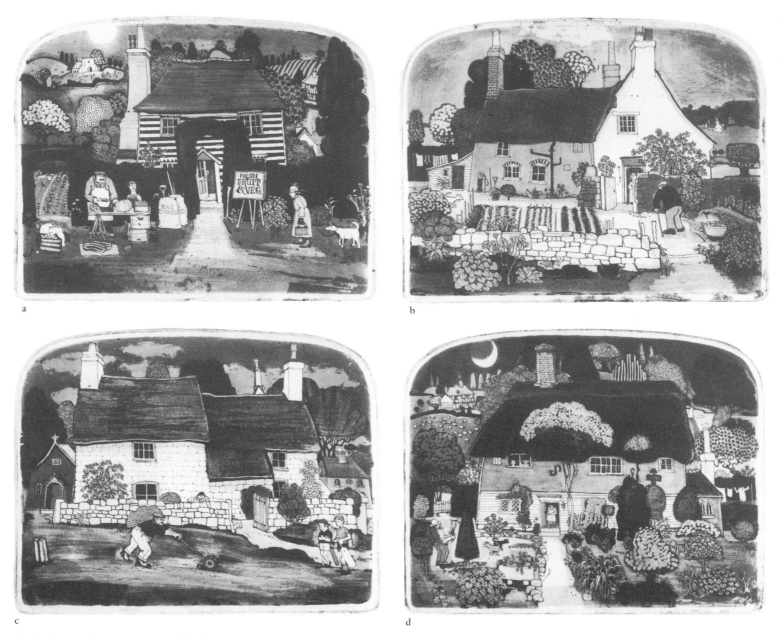

65a–h. *Cotts and Gardens*. May 1983. $5\frac{1}{4} \times 6\frac{3}{4}$ in. Limited edition of 300. A set of eight.

a. *Morning Rush* b. *Spuddery* c. *Groundsman* d. *Snippery* e. *Nightshift* f. *Mother Hen* g. *Moggs Court* h. *Outback*

These were all based on cottages in Kent, Sussex, Dorset and Cornwall which the artist recorded in his sketchbooks.

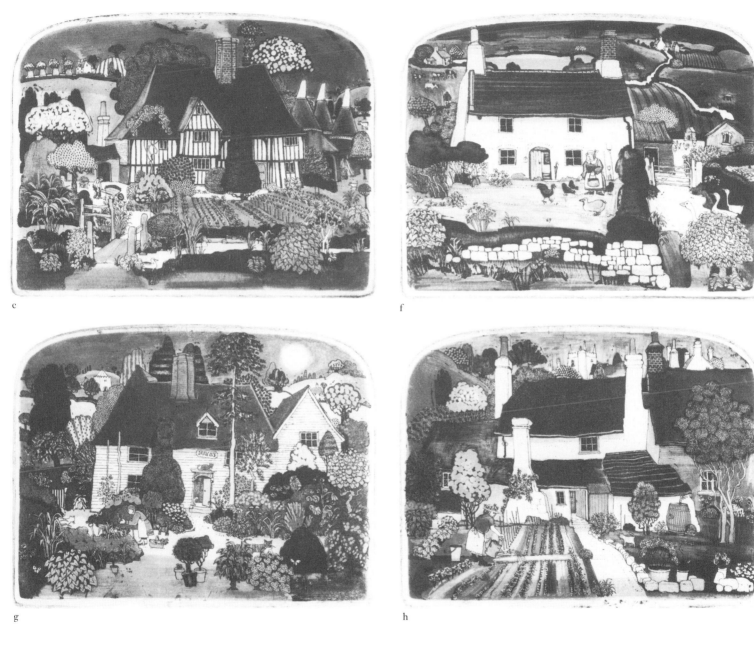

c

f

g

h

66. *Beach at Dungeness*. From:
Sketchbook Vol. 2.

67. *The Church, Hollingbourne,
Kent.* From: Sketchbook Vol. 1.

A bit of a grey day.

68. *Cottage, near Yalding, Kent.*
Sketchbook Vol. 8.

Nice weatherboarded cottage not
unlike our own, which is a simple
hall house with a 'cat slide' roof at
the back. Good old privy 'out the
back' with a proper zigzag top to its
door.

OPPOSITE
69. *Cadgwith Hill—looking up.*
Sketchbook Vol. 8.

Seven o'clock on Sunday morning
should be very quiet except for a
few fishermen (who have their day
'of rest' on Saturday as Friday is
'singing night'). However, a cottage
roof has collapsed in the night and
broken some of the pub windows
with its sliding roof slates, and cut
the 'phone wires. By the time I'd
got round to drawing, the locals had
all gone back to their cottages for
breakfast.

70. *Cadgwith Hill—looking down.*
Sketchbook Vol. 8.

A 1 in 4 hill, steepest on the corner
just before Bert Wylie's cottage.
Bert has worked here as a fisherman
all his very long life but is not
considered 'local' as he was three
weeks old when he moved down
from 'Up Country'—Plymouth.
The boat is the *Samantha Rose*,
with my friends Martin and Ron
Ellis checking the pots or
wondering who forgot the diesel.

Graham to be the 'Man of Kent' and to play out this role among the disarming
little characters and charming little houses which now populate his images.
His work has become a continuing idea running parallel with the develop-
ment of a way of life in Boughton Monchelsea. Cottages, gardens, pubs,
village shops, everyday pastimes and special events, the typical activities
associated with different times of the day, and with different months of the
year, the changing seasons marked by their traditional rituals, have all been
lovingly conjured up to illuminate *Les Très Riches Heures de Graham Clarke*.

Working with John Birtwhistle stimulated Graham to prepare his own
book of illustrated poems, published under the title *The Goose Man*, and for
this he devised his own typeface, 'Rural Pen'. The poems are imbued with a
wistful longing and contained exhilaration best summed up in *Dream Again*.

Of earlier days I dream again
Of smocked waggoners and gentle strength of horse
Of folded night sheep below the dark round hill
Of quiet cottage chimneys blue smoke spire
Of skipping children with their singing game
Of new thatched ricks against a star brown sky
Of hand made tools and hard work food
Of home made ale and song
Of purple cabbage rows and tender iron men
Of aproned womens love and childrens trusting grasp
Of course this all brings sadness but quietly drives my working hand.

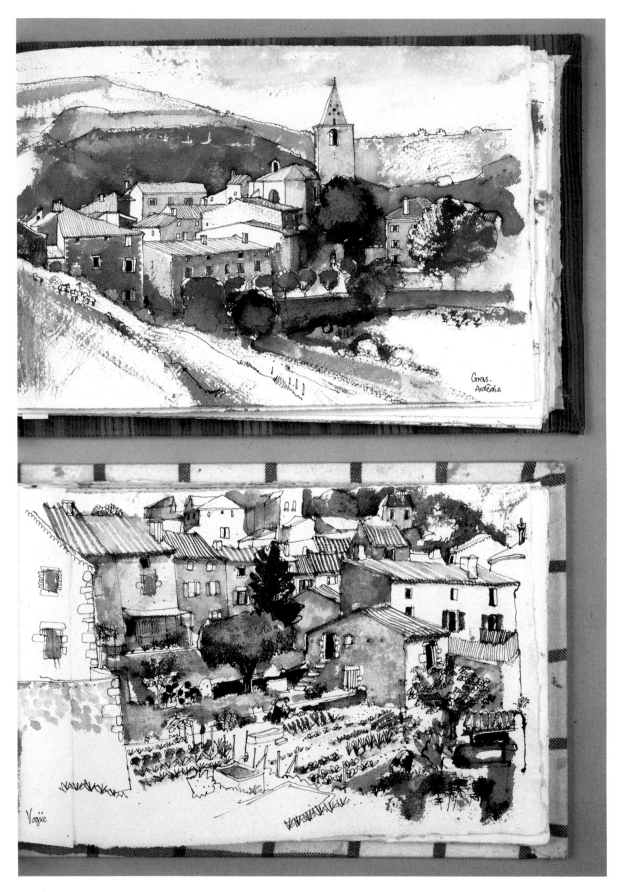

71a. *Gras, Ardèche, France*. Sketchbook Vol. 13. High in the arid mountains behind Ardèche lies this remote village. Parts of it are very primitive and it is much used by Biblical film makers seeking a Holy Land.

71b. *Vogüé, Ardèche, France*. Sketchbook Vol. 9. Jardins below the bridge.

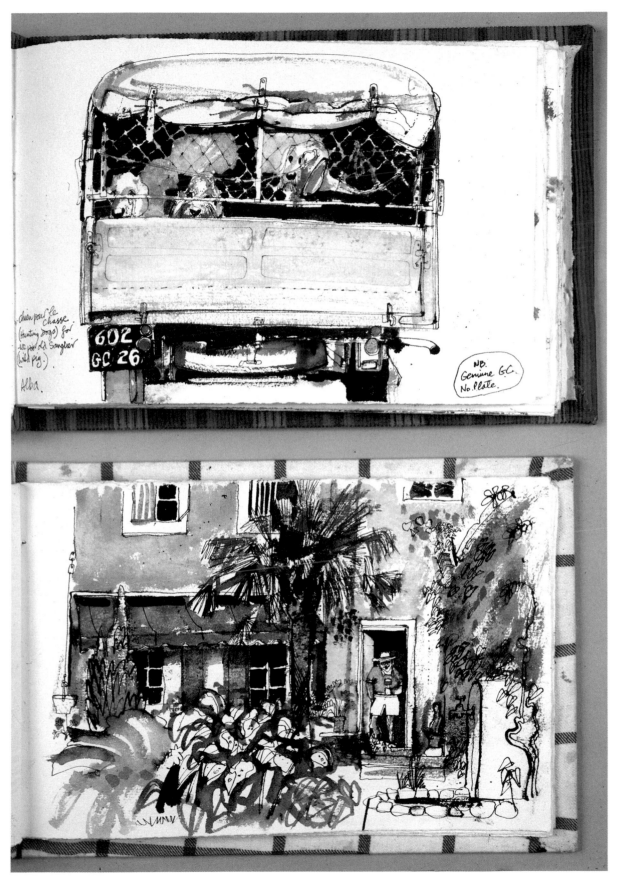

72a. *Chiens pour la chasse*. Alba, Ardèche, France. Sketchbook Vol. 13. These dogs are wonderful and so are the poor old *sangliers* (wild pigs). Why do we have to set one against the other?

72b. *Georges,* in his jardin, Vogüé Gare, Ardèche, France. Sketchbook Vol. 9. Georges Rigaud notre cher ami, le père de Phillippe, Marie Françoise, Thiery and Clothilde. Un gentilhomme.

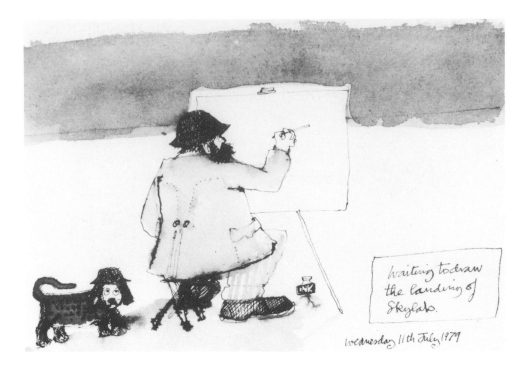

73. *Waiting to draw the landing of 'Skylab'*. Sketchbook Vol. 9.

I've been told that the job of an artist is to witness and interpret the fast modern world about him, and towards this noble end I was prepared to do my bit.

 The only part of Britain that the thing could have crashed into was our little bit on the most southerly point of Cornwall we were told. Down in Cadgwith, Sharkey didn't know whether to go to sea in his boat to avoid danger, or to stay with his café to put the fire out. An army-surplus dealer in Helston did a brisk trade in Anti-Skylab Helmets at £1 a time—cheap, eh?

At the end of the first poem in the book, about the boats and boatmen at Dungeness, he wrote: 'I love these things and words with pictures will ever seek to tell you how.' But it was an image without words, *Scenes From An Unwritten Book* (Fig. 45), which perhaps best expressed the direction of his thinking.

 Graham is a born story-teller. Every image seems to sprout a real or imaginary balloon. But stories need to be written down, to be correctly spelt, and to have a beginning, middle and end. Etching offered a safe way of avoiding these pitfalls. So he composed his images of many different scenes and incidents, and allowed the onlooker to wander round the picture, to devise his own sequence of events and perhaps discover a new or different story each time. It was as though all the scenes of a play were being performed on stage simultaneously, ceaselessly, under the proscenium arch of a toy theatre. In Graham's fantasy, the muddle of everyday life is faithfully recorded but, to reassure us, the dramatic unities have been duly observed and the subject matter carefully circumscribed. The scene is Little England, the action spreads over one unending day in the life of one man and his wife, children, friends and animals in some sort of suspended time and happy animation.

Man of Kent

In Graham's etchings people work hard, work hard at playing and, occasionally, relax. We never find any aggression, violence, anger, unhappiness or tragedy. The odd mishap may occur: a musician may fall over or a boy break his leg, but Graham never depicts disease, disaster or death. His churchyards are always serene, never morbid. 'They symbolize the history of

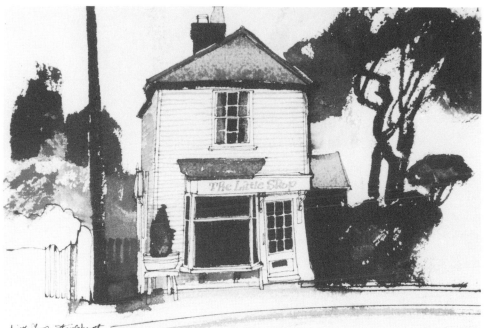

74. *The Little Shop*. Sketchbook Vol. 13.

Tiny weatherboarded building in Staplehurst, Kent. I used this later, as a basis for *Reg's Vegs*, one of the four *Shops* for Christie's.

those who have gone before in the cheeriest way', Graham explains. In conversation he avoids dwelling on unpleasant subjects, preferring to come to terms with them in his own mind and to help others to be equally positive. He believes that one, two or three happy people can, metaphorically speaking, link arms and spread happiness throughout the world. The idea of a chain of contentment is a seductive one, and very much an extension of Graham's own likeable personality. But how realistic is such an idea? His etchings seem, on the one hand, to suggest that the ideal is attainable and, on the other, to offer only an empty dream. Graham denies that his world is a fantasy. The image he finally produces may be synthetic, an ideal composite of many different villages and landscapes, as in *Garlec Arkham* (Fig. 53), but the ingredients, however filtered and edited, belong to his own experience, even the dragon—

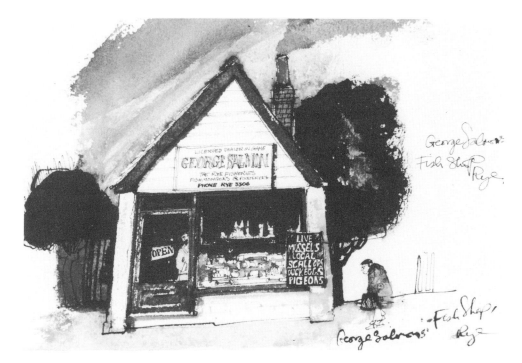

75. *George Salmon*. Sketchbook Vol. 13.

A nice little fish shop (I like fish shops) in Rye, Sussex. I've left out the buildings on each side, so it does look a bit too countrified.

76. *The Strand, Rye*. Sketchbook Vol. 5.

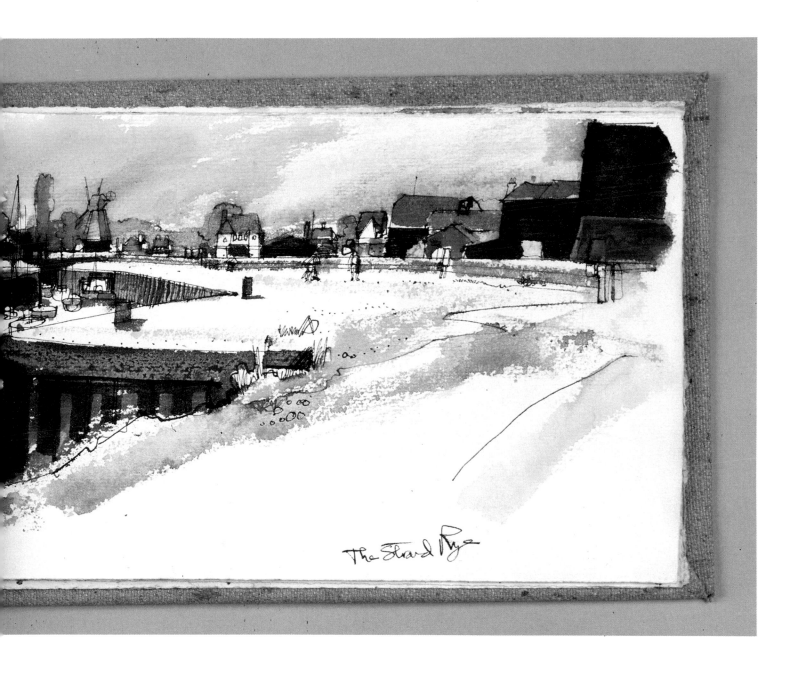

The Strand Rye

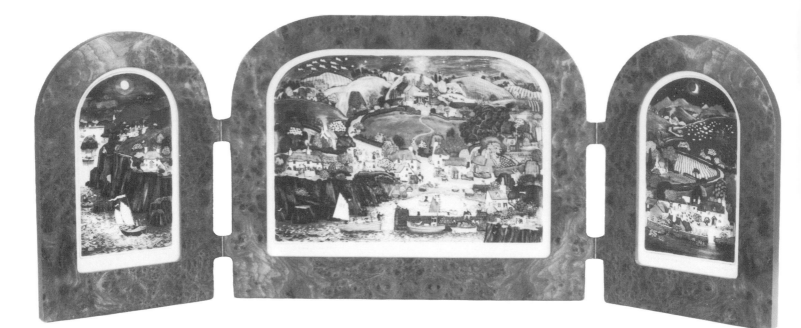

77. *Nativity Triptych: Magi, A Time for Dancing, Shepherds.* 1981. Size of central image, 13¾ × 19¼ in. Limited edition of 250.

A few were produced with burr elm veneered folding frames by Des Ryan ARCA, as in this illustration.

and even the host of glad angels who appear like shooting stars over the scene of Christ's nativity and the birth of the Clarkes' youngest child in *A Time for Dancing* (Fig. 77). This may, indeed, be the real world, a world of picnics and parties and life at its best moments. But what about its worst moments?

Graham is as concerned as everyone else, and often very anxious about war and famine, but indirectly so. By nature he is gentle and sunny; by nature, also, an artist. Had he completed his training and become a Methodist lay preacher, had he followed up his fleeting thoughts to become a politician he might have been empowered 'to banish the nasties', as he calls them, 'and to make the world a better place'. 'But' he says, 'I had no real talent for either, and not as great a desire as I have for making pictures. So, in order to make the world a better place, if that is my job, I make pictures which will make people feel happier. That's my contribution.' And as an artist he is in an even more privileged and influential position than either preacher or politician. He can improve on reality. He can purify the landscape for his audience and allow it to contain only those things which will gratify them. By responding to requests for a favourite cottage or a cat he can make the world to our specifications. After all, why restrict yourself to being Father Christmas just once a year?

Graham has sometimes been criticized for being an escapist. Life is not as tidy or as pleasant as he presents it. He would not disagree with this. Nor does he feel that people should be denied the pleasure of escaping into a beautiful piece of music or into a painting, if it makes them feel happier. But he also points out that dreams can come true—palpably so in his own case, in the

rebuilding of his cottage—and he extends that possibility to his audience in his etching *Dream Come True*. But if his dreams are, indeed, escapist, if they are of imagined islands and archipelagos, harbours and havens of happiness, of retreats and castles, they are not those of an eccentric individual who hankers after an ivory tower. Graham may wish to conserve his ideal in an ivory tower, but as a person he is actively involved in the community.

Pastoral Dreams

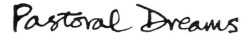

From an early age, Graham has been concerned that the artist and his work should be taken seriously. Art has to be seen as a job. And art, in his hands, has been made to answer to the charge that it is useless by being made to pay. Another aspect of this concern has been a wish to take his place as a working and contributing member of the community. He was as amused to achieve the status of Form Captain as he was, more recently, to be asked to chair his local parish council. He serves as a Governor of Maidstone College of Art and of Boughton Monchelsea's village school. Currently, he is an unsalaried director

78. *St George*. Sketchbook Vol. 13.

I've made two hobby horses of this kind—the first for the Queen's Silver Jubilee celebrations in 1977, and the better and larger one for our 1983 Carnival in Cornwall. As far as I know, mine are the only ones that do 'droppings', or 'ramblers' road apples', as my friend Arthur Feldman calls them.

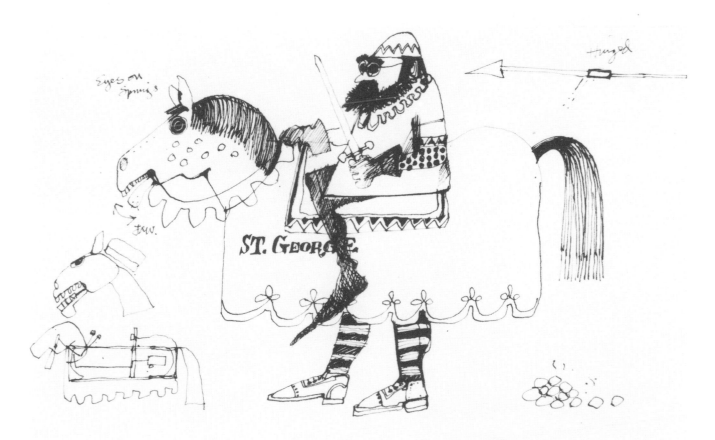

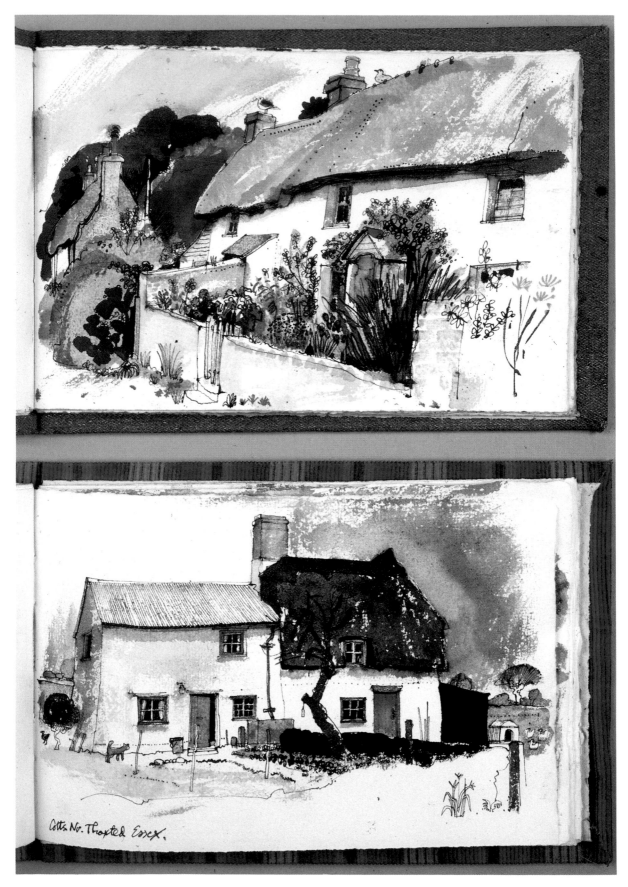

79a. *The Bolitho's Cottage, Cadwith, Cornwall.* Sketchbook Vol. 8. One of my favourite cottages anywhere. In front is a little walled flower garden crammed with sub-tropical plants, the coastal path passing the gate and then a flower-strewn cliff dropping 60 feet to the fishing cove way below.

79b. *Cottages Nr. Thaxted, Essex.* Sketchbook Vol. 13. I used this as the basis of 'Dew Drop Inn' (see Fig. 90b).

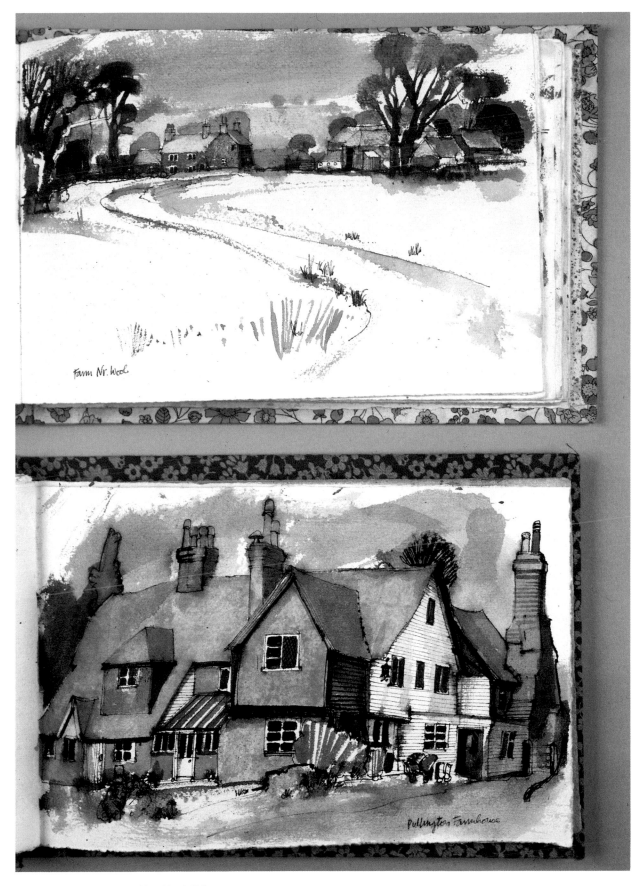

80a. *Farm Nr. Wool, Dorset.* Sketchbook Vol. 4.

80b. *Pullington Farm House.* Sketchbook Vol. 3. A fine ramshackle Kentish farmhouse near Benenden. It belongs to our friends Trish and Tom Scott (proper farmer).

of Hayle Mill, Barcham Green, which supplies and watermarks his hand-made paper. Here he has used the tangible evidence of his success to help run the company and to save the jobs of the fourteen craftsmen who work in this, the last surviving commercial hand-made paper mill in Britain. If his etching *By Appointment* (Fig. 62) was a gentle dig at himself, the hopeful village artist, that vision is now another dream come true: Barcham Green hand-made paper now bears the legend 'By appointment to Her Majesty the Queen'.

Where he has the choice, Graham avoids pomp and circumstance. He would rather contribute his etchings in aid of village improvements than sit for hours discussing an agenda. He belongs, mostly in spirit, to The Art Workers' Guild. And in 1980, he lent his support to the Shoreham Society's Campaign to prevent the M25 Motorway from ripping apart the North Downs. The etching he donated to the appeal, *Song of Samuel* (Fig. 55), shows the peaceful valley of Timberden at Shepherd's Barn 'as immortalized in the visionary paintings by Samuel Palmer during his stay in Shoreham 1827–1832'.

Graham is aware that some people may misinterpret his attitude to progress when he says that he 'dislikes science' and is 'wary of technology'. If the telephone is not his favourite piece of equipment, the reason is that it disturbs the peace. It may bring bad news, just as daily papers or news-readers may also be unwelcome bearers of unpleasant news. But they can be avoided or ignored. On the other hand, technology has its evident uses, and Graham's home combines, with taste, the romance of the cottage and all the conveniences of the modern house. It could never be claimed that Graham's feet are not firmly planted in the green and pleasant land of the late twentieth century. In 1981, his youngest child, Matilda (Tilly), was born in the local hospital. And the following year, he and Wendy expressed their happiness by forming a registered charity, 'Pedifund', to help provide an attractive environment for others visiting the now newly built hospital at Maidstone. Besides art works for the corridors and rooms, Graham's and Wendy's efforts have been directed in particular to the children's wing, and to providing toys, toadstools, mobiles and a child-high coin-operated telephone. All the work is unpaid and non-profit-making, and all contributions, both physical and material, are given free by the community. Graham is now turning his pastoral dream into a reality for the sick children, and for the elderly onlookers in hospital, by creating a small play-farm with wooden animals which will adjoin the children's ward. In this way the dream can be shared out again.

The fact that the dream can be made to exist alongside modern reality is appealing. And it is undoubtedly the key to Graham's own popularity and to the success of his work, not only in Britain, but in over a dozen countries worldwide, including three of the most highly advanced technological

81. The Clarkes 'at home'.

societies, West Germany, Japan and the USA. True, Graham has been asked—unsuccessfully of course—to make one or two concessions to national pride. Alex Gerrard, Graham's agent since 1973, describes how German dealers requested that Gothic spires should replace Anglo-Saxon towers, that barns should be tidily tiled and that there should be no holes in roofs. The Japanese admire his work for its delicacy and intricate detail, for its subtle use of perspective, and for the way it 'combines man and nature'. The Americans responded with confused politeness to the Plain Englishman's predictable prejudices, which Graham made such hilarious game of in his book on rural France *Goût de Grenouille* and which, in 1985, he transported to high-tec San Francisco.

The repeated invitation extended to Wendy and Graham to visit France came from Philippe Rigaud and his family, who live in the Ardèche. And in 1979 Graham set out on his first extended trip abroad. It was as testing a time for the French and for their sense of humour as it was for Graham, who forgot to pack his French and had to get by in shorts and a sun helmet, croaking with

82. and 83. *Reg's Vegs* and *Nice Stuff*. 1984; two of a set of four Shops published by Christie's Contemporary Art. $5\frac{1}{4} \times 6\frac{1}{2}$ in. Limited edition of 300.

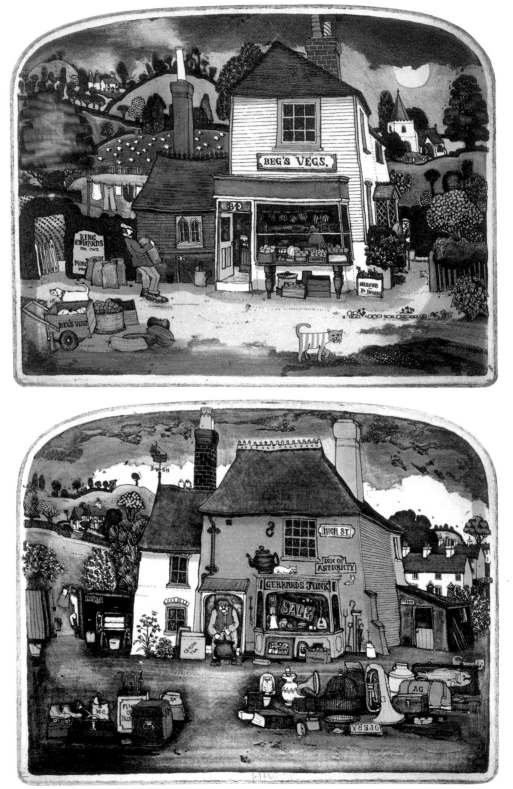

old tin bath of spuds.

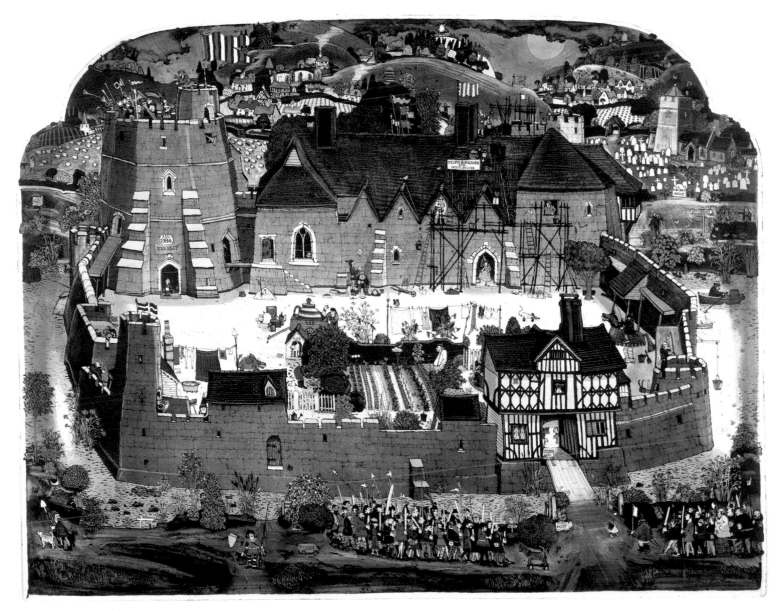

84. *Notte Todaye*. Dated on tower 'AUG. 1984'; published Autumn 1984. $21\frac{1}{4} \times 27\frac{1}{4}$ in. Printed on Barcham Green's hand-made Wealden paper in a limited edition of 400.

The starting-point for this etching was Stokesay Castle in Shropshire, but the picture is neither architecturally correct nor historically accurate. All complaints in neat handwriting to the artist, please. (See also p. 109.)

"the French workman with Lunch".

(As Seen in Villeneuve de Berg.)

optional extra.

the right intonation. Despite the grandeur of the terrain, Graham found the human scale of its divisions, the vine terraces, lavender patches and stone-walled garden plots very sympathetic. Nature came right to the door, and the human hand was so evidently at work in it that Graham felt completely at home in this Garden of France in which 'every glance frames a picture'. He has revisited the area on several occasions to paint, and to exhibit his works at Candide's 'Le Petit Musée du Bizarre'.

Time for Dancing

It is interesting to look back over Graham's development and to consider the extent to which the successful realization of his Pastoral Golden Age is due to sheer craftsmanship. As a graduate student, he used to visit the Victoria and Albert Museum and was particularly excited by the Indian miniatures he saw there. It was not just the diminutive scale which absorbed him, but the fact that the Indian artist could include twenty, thirty or even a hundred little

figures and animals in a distorted, but nevertheless true perspective. Graham's village-scapes, in which boats, sheds, cottages, trees, fields and hillocks are all stacked up under the narrowest band of sky, owe as much to the Indian miniaturist as they do to early panel painters, to Flemish sixteenth-century artists, or to Van Gogh in a painting like 'Harvest Landscape'.

Graham's individual solution to the problem of creating a warm and crowded environment while preserving a sense of space and depth, is to give each ingredient its own separate perspective. As the eye takes its walk and encounters each incident individually, the illusion created is very persuasive. The idea is an ingenious one and the secret of its success is contained in Graham's private sketchbooks, which he has been making, most consistently, since 1975. Here he usually records the line drawings which are the starting point for his etchings, and these demonstrate the fine sense of structure on which the whole balancing act of his work rests. Transferred to the copper plate, with all the techniques of etching and aquatint at his masterly disposal, walls may bulge, buildings defy gravity, suns and moons loom larger than life, but the final account is a powerful image which not only holds together, but which holds the eye. The eye may be teased a little and tricked a little, but the result is entirely acceptable.

85. *Cherry Picking, Alba, Ardèche.* Sketchbook Vol. 9.

Maurice's cherries are ready and we're helping to pick them. Our son Jason is up the ladder. Abigail has already filled her basket, and Marie Françoise with her *bonne Maman* is on the right. Pristi is the ginger spotted dog. Everybody helps except me. I'm allowed to work in my sketchbook. Being an artist appears to be a more respected profession in France.

cherry Pickers at Alba

86a–d. *Christmas Eve.* 1984/5;
published by Christie's
Contemporary Art. $13\frac{1}{2} \times 16$ in.
Limited edition of 300.

a. *Snowy*
b. *Excelsior*
c. *Fred*
d. *Are They?*

a

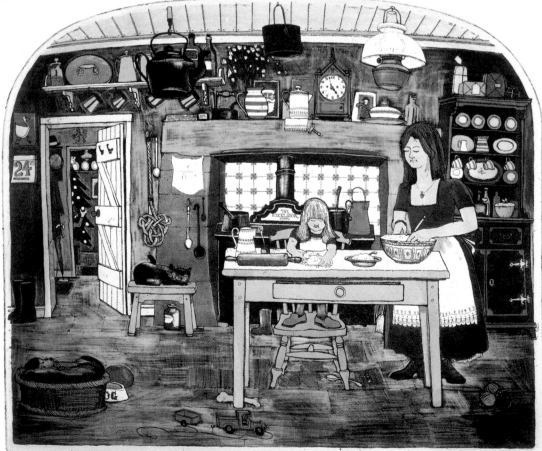

b

c

d

87. Preparatory drawing and notes
for *Pubs. No. 7. The Good Intent*.
Sketchbook No. 14.

OPPOSITE
88. Preparatory drawings and notes
for *The Gardener's Arms*.
Sketchbook Vol. 11.

Another drawing of this little
cottage in our back garden—
'Myrt's' or 'Up the Garden
Cottage' in this picture. In real life
we've turned it into a pretend pub,
The Gardener's Arms.

89. Gardeners for *The Gardener's
Arms*. Sketchbook Vol. 11.

Graham's treatment of light and shadow is equally illusory, and the
ambiguities thus set up add yet further to the decorative charm of his
etchings. This was as true of the early etchings as it is of the more recent work.
Graham now spends as long as three or four months on each large plate. The
images are much more carefully considered and composed and the plates
etched with a greater proliferation of detail. The random inclusion of more
and more incident is matched by an equally random application of colour. His
preference is for a print like *Sunflowers*, in which patches of colour appear
unexpectedly out of the blackness. The very fact that he avoids any attempt at
naturalism means that he relies entirely on a controlling aesthetic unity which
has been arrived at through the exercise of parallel strands in his work,
namely his painting and his cartoon drawing. Both of these reach an
impressive synthesis in his etchings.

His watercolour paintings are usually derived from topographical sketches
of single buildings, landscapes or seascapes, and these can be considered as
both a preparation for the etching and as a separate activity. What is
particularly interesting is that they are at once more serious and more
idiosyncratic. The medium is employed in an even more random and playful
fashion. Blotches and lines and colours have a life of their own, and Graham
enjoys controlling the accidental effects of watercolour on paper. These
passages of pure artistic pleasure are then programmed for the viewer by the
same clever, cartoon-like line that he employs in his caricatures and etchings.
In the latter, these moments of spontaneity and freedom are less obvious.

"The Gardeners Arms" pub Mol.

Village pub based on Myrtle in the Garden

Topiary
Smoke from chimney.
Faces at Upstairs windows, Myrtle
pretty Curtains.
Great TREE Variety.
other sunny patches.
Sunny patch in centre F.G.
Animals Birds, Groups.
Garden Tools etc.
Wheelbarrow, Watering Can etc.
Buckets
Beer + Bottles etc.
(Mid Kent Boys as in Teapot Clipper)
V. Leafy.
Washing in B.G.
Tech.
Brick/Stone Wall open inte + aqua chimney
Detail in Line.
Open bite Textures pre-aqua
Line weight Contrast ∗ F.T.B.E. Ratio.
Counterchange.

Birds

TS A R

The Gardeners Arms
FINE ALES AND STOUTS

THE GARDENERS ARMS

Shadow Lettering

Gardeners

Graham Clarke

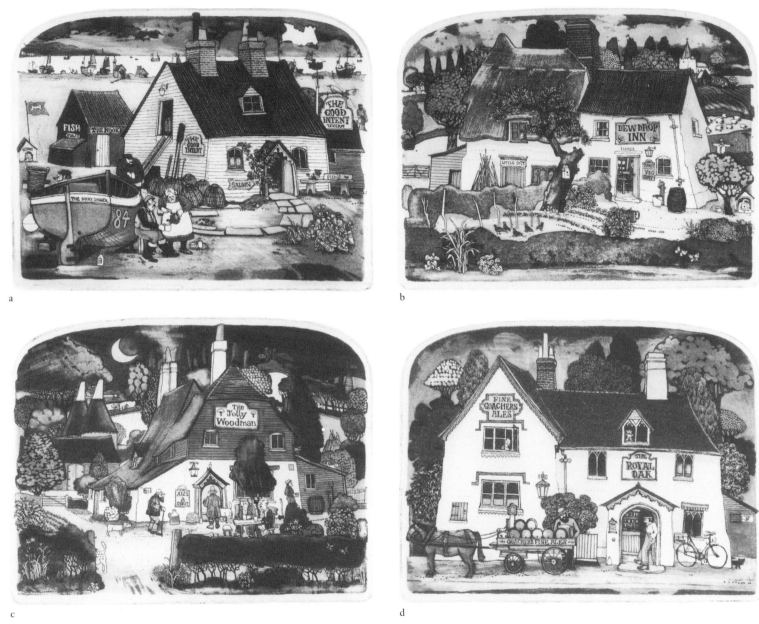

a

b

c

d

90a–h. *Outside Inns.* 1984. $5\frac{3}{8} \times 6\frac{3}{4}$ in. Limited edition of 500. A set of eight pubs.

a. *Good Intent* b. *Dew Drop Inn* c. *Woodman* d. *Royal Oak* e. *Drakes* f. *Breeze* g. *Rifleman* h. *Gardeners*

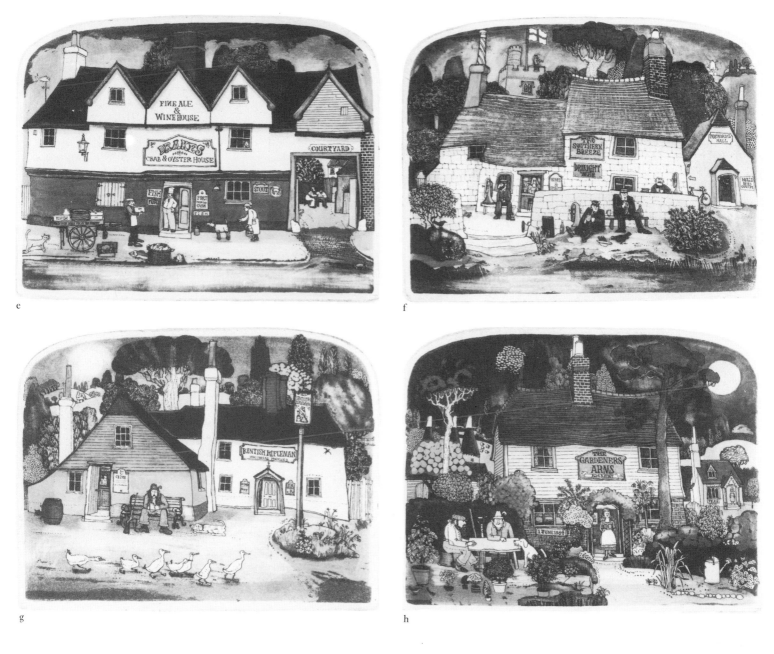

c

f

g

h

They are there, but the tension between the use of the ink and the deployment of a controlling line to assist the story-telling has to be more cannily calculated.

The appeal of a story—or programme, to use a musical analogy—is compelling. Graham has overcome his inhibition about spelling and, since 1977, has supplemented the etched narration with an unconventional guide, or *Notes for the Interested*. Many of these waggish commentaries have been beautifully typeset with more than a dash of humour by a long-standing friend, Graham Williams, at his Florin Press, and they now complete the entertainment. These sheets were started as a way of anticipating and answering some of the many enquiries and comments he receives, but they have now evolved an almost independent existence in booklet form. With *Gopher Ark Ararat*, his second triptych, published in 1983, Graham returned to a favourite story on which he completed his thesis at the Royal College of Art, the story of Noah's Ark. The notes are printed in the form of a book of Bible commentary and Graham takes on the mantle of a village explainer of great mysteries. But, to be precise, he does not explain anything; he invents, and relies on our knowledge of the true story to exploit its humorous aspects. The entertainment he offers is not just a momentary joke about cramming a veritable zoo of animals into a small space, but a way of dealing with disaster. 'Humour can be as strong a force as religion in making things better', Graham says.

Religion is one of the strong, underlying currents in Graham's work, but he

would insist that it is no more important than domestic bliss, love of the countryside, animals or children. It has its customary place like everything else. In his first triptych, *Time for Dancing* done in 1981, the story of the Nativity was presented as a kind of Cornish folktale, in the tradition of Flemish genre painting. Like Noah and the Flood, this is a timeless story which Graham believes belongs to all of us, and to be about all of us. Pictures like *Nethercott* (Fig. 42) work in the same way; the children sit round the hearth listening to Grandmother, the family matriarch, teller of tales, transmitter of folklore. Graham gives us Clarke-lore, with its suggestion of ancient truths; he gives us *Christmas Eve* (Fig. 86) and the magical days of childhood innocence and unquestioning belief in those truths.

There is a little chapbook which Graham reprinted for a young German student, *The Surprising Life and Most Strange Adventures of Robinson Crusoe, of York, Mariner*, and it concludes with some words which Graham must always have 'half known': 'In this narrative we find a remarkable chain of Providence, sufficient to excite our wonder and astonishment. From which we may learn the advantages of early habits of patient industry and perseverance under the greatest difficulties.' Like Robinson Crusoe, Graham can attribute his success to good fortune, to a 'Woman Wensdy', and to hard work—to 'busyness' in its original sense. For Graham is a factive man.

It can also be said that Clarke-lore has chimed remarkably with post-war culture. If at The Royal College of Art he was considered old-fashioned, he was so in the wake of a scholarly revival of interest in the Victorian and, later,

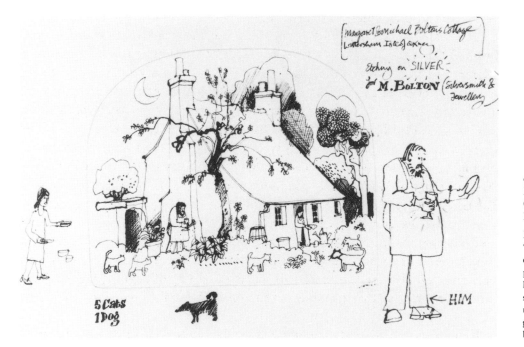

91. Preparatory drawing for Margaret and Michael Bolton's Cottage, Wittersham, Isle of Oxney, Kent. Sketchbook Vol. 12.

Michael, a silversmith, wants a 'bespoke' etching in an edition of ONE, done on a solid silver etching plate. I mixed nitric acid and hydrochloric acid 'to be on the safe side', and it etched well but threw up a tremendous residue of greenish-white sludge—didn't bother to taste it . . .

92. *Sceautres, Ardèche, France.*
Sketchbook Vol. 13.

A remote village, its houses
clustered around the 'plug' of a very
extinct volcano. Down behind this
great rock is the Auberge where we
eat as often as we dare. It's usually
full of mad dogs, brigands, itinerant
one-man theatres and little children
who poke their fingers in your food.
I always have goat stew, and am
pretty certain it's the same one
heated up year after year.

Sceautres
Statue of Our Lady on the Mountain Top.

93. *Valvignières, Ardèche.*
Sketchbook Vol. 13.

Among the mountains south of
Alba is this nice walled village and
Madame Rosette's cosy restaurant.
No menu at all, just a delicious
succession of surprise dishes
banged onto the table along with
her compulsory rosé wine. Regular
customers may give her a kiss on the
way out.

Valvignieres Ardèche

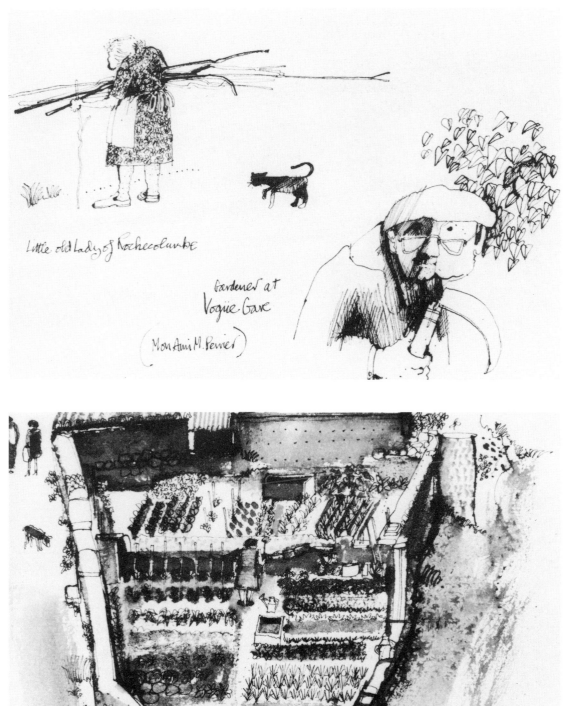

94. *Little Lady of Rochcolumbe and Gardener at Vogüé Gare, Ardèche, France*. Sketchbook Vol. 9.

Little old Lady of Rochecolumbe

Gardener at Vogüe Gare

(Mon Ami M. Perrier)

Garden below the bridge at Vogüe

95. *Gardens below Vogüé Bridge, II*. Sketchbook Vol. 9.

As is apparent here, these neat little gardens are not adjacent to the owners' houses. Nor are they allotments, rented as in England. They belong to the very cramped houses inside the village walls where there is no room for growing plants except in pots on the balcony.

Edwardian periods. The revival had its serious as well as its popular publicists, both of whom were typified by John Betjeman. Nostalgia caught many people in its cosy hold, partly because there was a generation which remembered and yearned for pre-war days, and partly because the revival of interest in the National Heritage and its colourful institutions, in traditional crafts and recipes, was infinitely more appealing, comprehensible and reassuring to the popular imagination than what the brave new modernistic world had to offer.

Graham Clarke attracts all these interests and longings, which find their roots and their natural centre in the countryside. He has always lived in the South of England; he is a self-professed 'Man of Kent'. And, understandably, he wins many admirers in his own 'parish'. But the charms of his house-style also exercise an appeal which goes far beyond a delighted recognition of the local and particular. It works its magic on all those who, like Graham, cherish the dream of a peace-loving world which will preserve its 'soldiers in their cheerful red coats outside Buckingham Palace, and abolish all fighting'.

Clare Sydney

Notes on the Production of Arched top Etchings

All my etchings are on copper plates which are cut, shaped, bevelled and polished. I prefer to do this myself when time permits, but it's a job which can be delegated.

The plate is 'grounded' using Rhind's Dark Etching Ball, and this acid-proof layer is smoked to darken it before drawing with the needle on the plate. I prefer not to have too exact an idea of the completed image, but to allow it to grow as I work from the brief drawings and notes in my sketchbooks, and ideas in my head. Small blemishes and errors can be corrected with stopping out varnish.

To etch this initial line stage of the image, I use Dutch Mordant (hydrochloric acid with additions) and usually commit the plate to the acid only once. More recently, however, I have been putting larger plates in three or four times, adding or substracting areas and lines as required between each stage—for a richer effect. The plate can then be cleaned off and the first proof taken.

Aquatint is employed to achieve tone. Powdered resin is applied in an aquatint box; after heating, each stage is 'stopped out' and etched in nitric acid—usually about twelve separate stages—sometimes going beyond the expiry of the minute resin particles back to bare metal and so to 'open bite'. On occasion, I use open bite in the more direct traditional way. The plate can then be cleaned off and proofed again. It is likely, and this is normally deliberate, that the image will be far too dark, and four or five stages of scraping, burnishing and proofing are required before the image is acceptable. When ready, half-a-dozen finished proofs are printed before the plate is 'steel faced' to preserve its surface qualities. The edition is then printed. This is always expertly done by Graham Everden and his assistant on two copperplate presses identical to my own.

Meanwhile, I plan, and mix in large quantities, the dozen or so hand colours that are used on each image or set of plates. When one example is ready, Stephen Mead, my hand colourist, takes over, diligently working through the whole edition, and taking the utmost care over a period of several months. As soon as some of the work is ready, I check, title, number and sign each print, usually in batches of 20 or 30 until the edition is complete. The plate can then be cancelled in such a way that further printing would be impossible.

Most of the editions are then distributed by my good agent, Alex Gerrard or by my friends at Christie's Contemporary Art. Without the encouragement of their director David Case, and the hard work of my printers and hand colourist, Graham Clarke & Co. would not operate.

Notes on Notes for the Interested

As my arched top etchings became more narrative, various kind customers asked for explanations and interpretations by 'phone, letter or, worst of all, face to face. The *Notes* seemed to be required and, in fact, to my surprise, give me great pleasure to write—they are so undemanding. I don't even have to tell the truth, let alone struggle with grammer and speling. . . . They are usually written in parallel with the work on the etching itself, and only occasionally written after the plate is complete.

Once composed, I normally pass them to Graham Williams of the Florin Press, now at Biddenden. He is imaginative enough to treat each one as a completely new typographical challenge, and with his great skill sets and prints them beautifully. As will be noticed, some notes, those written while Graham was getting himself married to his wife Nina were in fact designed elsewhere by our dear friend Teddy (Edward Hughes) and printed by good old Grammer & Co. of Sevenoaks. (Alright Dave?)

Notes for the Interested

The Goose Girl (Fig. 24).

Although this is by no means a topographical scene it is certainly based on the beautiful Bodiam Castle in Sussex built in 1385 by some person called Sir Edward Dalyngrigge. It does have a moat (rather broader than this) and the river Rother flows behind it with hills beyond that. There the truth gives way to imagination. When I first thought of the picture some months ago it was to have been a battle scene rather than the mild confrontation that seems about to happen here. Somehow the fierce fighting I'd planned seemed to give way and the usual tranquillity of rural life intrude more and more as I drew the plate. On this print I have used a new hand colouring which will be much more permanent than any other of the usual watercolour processes; for this I am indebted to Geo. Rowney & Co. I appear in the picture four times and my dear wife Wendy appears once.

Archipelago (Fig. 25)

For some months I have been planning one of my largest arch top images, depicting a group of pleasant islands, busy but tranquil, small but self-sufficient. This is it.

Of course it is not a real place but nevertheless owes most to well loved Cornish topography. But other areas of my work have their influence, like the Kentish hop kilns (oast houses) and the Sussex luggers. In addition it re-introduces themes from some of my earlier prints. At one time I was going to call this picture *Andre's Dad and the Miraculous Draught*. Andre's Dad is, as you can see, in his fishing boat wondering why the fish are apparently so eager to be caught. Nobody knows. All I can say is that I really have seen a shoal of mullet swimming frantically towards unknown delights, with their heads well out of the water and a slight smile on their crispy chops.

Andrew himself is here with his pixie type Cornish

shovel, he is standing with our three children looking at Mr Bean, the scarecrow, standing amongst the cabbages. Many other friends appear without permission. My Wendy is moonbathing and I'm drawing as usual.

The Sailor's Return (Fig. 29)

Dear Mr Christies Contemporary Art,

As you know I have been planning one of my arch top plates for you to publish this Winter. A large work involving the usual clutter of careful damage. A narrative picture showing a sequence of incidents following the return of a sailing man after a long voyage. The ship on which he sails anchors in a small port; you will enjoy searching the coast of Cornwall for this place but will not be able to find it as I made it up. I thought I ought to mention this as I heard the other day that some enthusiastic collectors purchased a copy of my 'Porth St Ruan' and became anxious to see the real thing, unfortunately they travelled from Southern Germany all the way to Cornwall on a 'Wild Chase Goose'. Anyway the sailor is rowed ashore in a skiff laden with trunks, cases, a parrot and some money, and is relieved of these by the landlords of the various taverns, old fishermen down on their luck, a nice vicar hoping to stop his church falling over, naughty ladies, a man with a really good idea, and several children who keep calling him daddy. He at last reaches his cottage and good wife whistling 'The Wild Rover' in F major by this time. . . . This then was the plan for your etching—and a very good plan too—it's just a pity I didn't carry it out, however this one is somewhat similar and will probably keep you going. To avoid any possible confusion in your books
I've still called it
The Sailor's Return.
 Yrs. Graham Clarke

P.S. It's definitely not true about Seagull Pasties.

The Nasty Tern (Fig. 32)

Dear Mr Art,

Thank you for your letter and the threatening 'phone calls. Just as you were led to expect, the subject of this print is the Clarke & Co. entry in 'The Carnival'.

Our float was originally intended to portray Mankind's Eternal Spiritual Quest to Understand the Meaning of the Universe. As the great day approached we altered it slightly and dressed up as pirates. Luckily for me old Icarus Fenner and Dovetail Dez were down from 'up country', so we weren't short of skilled men when it came to building the galleon.

This shipwrighting part went surprisingly well. We simply sawed an old 16 ft rowing boat into three, threw the middle bit away, strapped the front and back together again and added masts, rope ladders, scuppers, cannons, crowsnests and some bilge rats. We had to cut holes in the floor for our legs to poke through of course—then, with the addition of braces, the whole thing could be worn like a gigantic three-man wooden trouser. It was to be three-man but Jason voluntarily threw himself overboard for lack of space just before we launched.

Some years ago Higbee was kind enough to give me a fine stuffed seagull, actually a tern, so we stuck him on top of the mast (the bird, not Hig) and cleverly named the vessel 'The Nasty Tern'. Following a rather half hearted attempt to break a bottle on her bows we drank the scotch as a precaution against scurvy during the voyage.

You can see us in the centre top of the picture just entering the Rec. (the only flattish piece of grass south of 50 latitude on the mainland of Gt. Britain). We are being followed by my Wendy in her Jubilee corsets pushing a nice barrowload of little mermaids. You will notice that a few people are already in the Rec. to greet us but most of the several hundred spectators plus the Silver Band, three dozen Vikings and a boy dressed as a pig are still round the back of the post office—otherwise I'd have put them in.

Fortunately the sensible organisers made sure we all won first prizes or there would have been even more trouble.

Right at the bottom of the picture Smarty Mart, the most Crafty Catcher of Cornish Crustacea, is politely indicating to a passing cormorant that he has just landed two chests full of crabs. Apart from that, life is staggering on pretty much as usual down here. Jack's pub will be open in 55 minutes and that appears to be the main news of the day.

 More again soon,
 Yr. Vry. Obt. Svt. & Wt. Abt. Sm. Mny.

P.S. Incidentally, it was one of Mart's prime specimens

that won the much coveted Best Dressed Crab Award in the 1980 O'Limpet Games. So you can see you're not mucking about with rubbish.

Goût de Grenouille (Fig. 33)

Dear Mr Christies Contemporary,

Well, as you can see from this lot they got me to go at last. I must have told you before about these charming french people that we've known for years and years and how they kept nagging me to go all the way to their home village in the Ardèche to do some drawing. I finally gave in and we mounted the now famous KREPTORf expedition (Kentish Ramblers Enforced Pilgrimage To Rural france) and actually flew in a plane from Airwick to Clermonferrand. Then braver still drove along french 'roads' to the Ardèche which turned out, by the way, to be a very pleasant area of the globe. I dare say some of you up there have heard stories of this france, how they eat snails legs and ride bikes covered in onions all day etc. etc. It is by no means all untrue and as you can see from the etching herewith, it is indeed a very strange place (no wonder it's a foreign country). As you well know 'the Etching Tool has never been known to lie' so although much of what you will see here will be confusing to say the least it's all 'veritable' as they say.

In order to help you and, of course, those wonderful people who you tell me buy my pictures, understand completely, I'm writing a little book also called *Goût de Grenouille*, freely translated as *Taste of Frog*, but subtitled *A Plain Englishman's Observations on Rural france*. A slim volume padded out with blank pages and plenty of sketches. If you want to purchase a copy be sure to let me know. It should be ready earlyish in the New Year and won't cost much more than a bottle of Vin de Table.

Yours hopefully,
Graham Clarke

(The book *Goût de Grenouille* was published as A Neezerbax Book by Ebenezer Press in 1981.)

Left Right, oops! (Fig.38)

We chose to celebrate the Silver Jubilee of Her Majesty Queen Elizabeth the Second by presenting the last 25 million years of our own village history, in the form of a 'Grand Parade' followed by a 'Street Tea' for the children and old people, then games and later dancing for any survivors.

'The Stagefrights', our drama group, surprised us with a full size bionic iguanodon and dressed as cavemen to add extra credibility. . . . Our youngest parishioners, 'the under fives', dressed as Ancient Britons it being pointed out that 'people were smaller in those days'.

This 'Grand Parade' had to be lead by our Silver Jubilee Band, the word silver refers to the Jubilee not the metallic colour of the instruments. . . . In my opinion we make André Previn and his Classical London Boys sound like the Junior Church Lads Brigade Bugle Corps tuning up, but then I'm dedicated.

Nethercott (Fig. 42)

Dear Arty,

Some time ago, while eating my tea, I received one of those unexpected 'phone calls from a person with the unlikely name of Morpurgo. He claimed he was 'phoning all the way from the dells and dingles of N. Devon and did not need to reverse the charges, he went on to say that he'd written this narrative poem which he hoped some day would be made into a book; then admitted that, although quite good at rhyming and even spelling, he had to confess that he was just a perfect dimwiddy at drawing* and would I do it. He spoke in an unusually gentlemanly manner so I failed to slam the 'phone down quite soon enough, in fact I was still laughing at the name Morpurgo and choking over my bloater paste sandwich when he got to the part about how he and Mrs Morpurgo had collected my glorious etchings for years and how brilliantly clever they thought I was. So here we were then dealing with people of considerable discretion, talent, taste and possibly wealth. Any of my friends will tell you I'm not bothered by sincere flattery (it's all water down a duck's beak to me) so I persistently refused to collaborate, and here it is.

His lengthy poem concerns a little girl in the late 1890s (the old lady in my etching) who falls foul of her fearsome Sunday School Teacher a Miss Wirtles; later the girl is nearly burnt as a witch by the village lads, then wins a race on her dad's cart horse and promptly falls into the village duck pond—good eh? How the Morpurgo can stretch this sort of material into eighty-seven verses is a marvel to me but it's really excellent stuff

nevertheless. A book of his poem and my pictures is soon to be published (really) and incidentally the text is printed in my specially designed typeface, which is naturally named Morpurgaloid Bold. So it's going to be worth every penny. Meanwhile here's my etching . . .

Yrs paramagniloquently (and give our love to Mrs Art)

Graham Clarke

*A fact which he later proved beyond all doubt when he drew a map which was supposed to help us find his farm.

(*Miss Wirtles Revenge* by Michael Morpurgo, illustrated by Graham Clarke, was published by Kaye & Ward, 1981.)

Uncle Sid & the Limpet Racers (Fig. 52)

I trust you'll forgive the semi-educational nature of these notes, but in these days when we are told we must expect more leisure we should naturally support and encourage specialist sports and pastimes.

It's difficult to see why limpet racing is not more popular and has not become a truly national sport, for one can scarcely imagine a more thrilling spectacle than a field of incredibly fit thoroughbred limpets going at full tilt. Compared with horses or dogs these are less expensive to purchase, simpler to feed and by contrast, a pure pleasure to muck out. It's true they can be awkward to transport but they are loyal even affectionate and are not prone to biting or distemper (let alone emulsion).

Some of my regular customers will have already heard of Educated Elijah, Whitstable's Yodelling Limpet, so justly famous for his impersonations of well known vocal stars such as Vera Lynn, Engelbert Humperdinck and Humble Bert Emperdinck, not to mention our very own Mervyn Cruddy the Gaumont Caruso and an all time grate. It's a little known fact that apart from Elijah's vocal prowess he was a top class middle distance runner . . . It was a cruel blow that, at the peak of his singing career and just prior to the O'Limpet Games, he met such an untimely end in a Moules Mariniere while touring in Northern France. I'm afraid it was just another (if any be needed) example of Gallic Maladroitness. But what about Uncle Sid? I hear you say.

Yours Indelibly

Graham Clarke

(None genuine without this signature)

(Designed by Edward Hughes and printed by Grammer & Company.)

Quite Cricket (Fig. 56)

In my opinion formal sports are all very well as a means to introduce suffering schoolchildren to the less pleasant aspects of human nature and as a means for middle aged show-offs to keep hospital casualty depts. on their toes, but they don't get a very high mark on my score card. An exception though is cricket.

Cricket's different; I don't watch it or play it of course, but I do admire it tremendously and most of the noble oicks and varmits who thrash around on village greens across the summer landscape, do it for the very best of reasons, I feel certain.

.

My best tea lady sits under the tree. I'm certain some of you clever cricket dicks will be anxious to point out that the umpire at the bowlers end is facing the wrong way. I know, I know. My excuse is that he's exceptionally short sighted in common with so many of his breed—referees, traffic wardens and the like.

Apart from a passing resemblance to W. G. Grace in the beard area, since my involvement with the Pre-Skifflite movement I've had little to do with the game since I was self appointed Captain of Leftovers during weary Wednesday afternoons at Penge Grammer School thirty years ago. I'm sorry to say I'm sorry but I can't say I'm sorry. I'm happy to leave the actual playing to this wonderful team of heroes herewith.

Yours sportingly,

Graham Clarke

Captain of Leftovers (Retired)

(Designed by Edward Hughes and printed by Grammer & Company.)

Notte Todaye (Fig. 84)

For those patrons who want to know more concerning the happenings in the scene here presented I can do little worse than draw your attention to Professor A. Ristotle Bogwicket's fine book on the subject of everyday life in the Medieval Castle. *Feudal Doodles* (Fungal & Peabody 1862) will be known to all true scholars and gentlemen but for the rest of you I quote here from page 29863.

'Whenever the lord of the manor was absent from home either visiting another of his estates, fighting for or against the King of the day or merely off on the odd crusade. The person left to run the castle in his absence and to manage his lords affairs was the steward. Life was not always easy for him. An ancient letter discovered by my good self Professor A. Ristotle Bogwicket A.R.C.E.* in the Shropshire County Archives will serve to illustrate.'

* A Real Castle Expert'

'Good My Lord Sir Lawrence
Notte an eaſy daye at your caſtle todaye my Lord great ſtone cannon balle or ſome ſuch come hurtlinge over ye wall bye Godde and we have ye builders inne on account of a fair old hole in roof of your great halle Mr Pillager of Villein & Pillager general builders Ltd "moderate work at firſt claſs prices" ſay no ſtructural damage to ſpeak of juſt a few battens and the odd ſlate ſo to ſpeak do it as ſoon as he can he ſay So I ſay do it quick pleaſe Mr Pillager afore his Lordſhip come home in four years time aſkinge why things look ſo ſlovenly like you uſually do begginge your Lordſhips pardon he ſay he'll take the men off another jobbe right away ... although Bazil ye Brickie prefer "ſomethin a little ſtronger" the reſt of the men are now demandin "tea" apparently ſome kind of dried leaves ſoaked in warm water with cows milke (new idea from foreign parts no doubt) ſo I ordered forty-eight extra pints off Micke ye Milke my Lord

.

Weather a bit dampiſh but not too bad conſideringe I expect it is ſtill nice in Holy Land give Saladin ye Turk one acroſs ye back of his earole from me and ye lads at next 'round of talks'

Truſtinge this reaches you as it leaves me

your good and faithfull ſervant

Rufus Spratling (ſteward)"

Index